SEW DOG

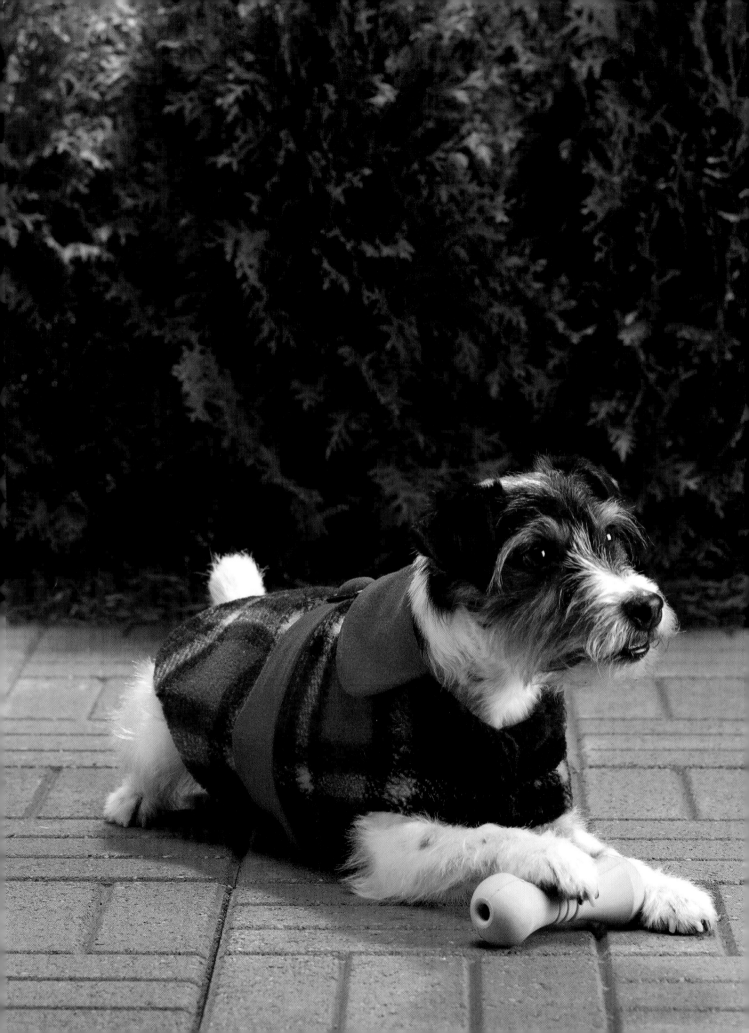

SEW DOG

Easy–Sew Dogwear and Custom Gear for Home and Travel

JENNIFER QUASHA
with Pamela J. Hastings

CREATIVE
PUBLISHING
international

CHANHASSEN, MINNESOTA

Vice President/Publisher: Linda Ball
Vice President/Retail Sales: Kevin Haas

Executive Editor: Alison Brown Cerier
Managing Editor: Yen Le
Page Design: Deb Pierce and Rose Woo
Senior Editor: Linda Neubauer
Photo Stylist: Joanne Wawra
Director of Production and Photography: Kim Gerber
Photographer: Tate Carlson

Watercolor Illustrator: Jean M. McNiff
Pattern Illustrator: Margaret W. Giunco
Copy Editor: Donna Hoel

Library of Congress Cataloging-in-Publication Data

Quasha, Jennifer.
 Sew dog : easy-sew dogwear and custom gear for home and
travel / By Jennifer Quasha with Pamela J. Hastings.
 p. cm.
 Includes index.
 ISBN 1-58923-169-4 (soft cover)
 1. Sewing. 2. Dogs—Equipment and supplies. I. Hastings,
Pamela J. II. Title.
 TT715.Q37 2004
 646.2--dc22
 2004015259

Printed by Quebecor World:
10 9 8 7 6 5 4 3 2 1

CONTENTS

Jennifer Quasha is an award-winning author, a contributing editor at *Dog Fancy*, and a regular contributor to *Your Dog* magazine. She is the author of *The Dog Lover's Book of Crafts* and *Don't Pet a Pooch While He's Pooping: Etiquette for Dogs and Their People*. She also has written forty-three children's books, including six about crafts and three about dogs. Jennifer lives with her dog, Scout, in Connecticut.

Pamela J. Hastings has written *No-Sew Fabric Décor* and six books on home décor sewing. Pam is a spokesperson for Viking Sewing Machine, Velcro USA, Waverly, and Rowenta. Her sewing career began with ten years in the education department of Singer. Pamela appears regularly on home shows and has written articles for *Family Circle*, *Woman's Day*, *Good Housekeeping*, and *Better Homes and Gardens*. She lives in New Jersey.

Why Sew for
YOUR DOG?

There are many practical reasons to sew wearables and gear
for your dog. Perhaps you've found that no store sells a coat
that will actually fit your dog's body. Maybe you've admired
those chic carrying totes, but won't pay the hundreds of
dollars that boutiques are asking. You may wish that your
dog's bed wouldn't clash with the colors in your family room.
You might enjoy dressing up your dog for Halloween or a
special occasion, but want your best friend to enjoy the
costume, too.

The most compelling reason of all is the warm and fuzzy
one: Because you enjoy pampering your pooch. Nothing says
love like making something special for your dog.

Sew Dog makes it easy and lots of fun to sew over two
dozen projects like coats, costumes, beds, travel gear, furniture
protectors, and a safety vest. It includes projects as practical as
a car-seat protector and as wonderfully silly as a tux.

I've designed each project to be different and better than
what you could buy in a store. I know what makes a dog
product useful, safe, and high-quality because I research and
write reviews of dog products for magazines. I've examined
hundreds of products of all kinds and have seen the good, the
bad, and the ugly. So I've very much enjoyed designing

products that are packed with features and supremely comfortable for the dog.

For these projects, no restrictive bands of elastic are used around the neck or legs. Many items attach by slipping the dog's collar through a casing. Clothing closes with Velcro so you can quickly get it on and off. (No more looking for a buttonhole through a long coat.) I've included lots of travel gear to make it easier to take your dog wherever you go, which is where your dog wants to be. There is gear to make life easier at home, too, such as a paw-wiping mitt and a furniture protector. Just for fun, I've included some gifts like a treat bag and a Christmas ornament that frames your dog's picture. All the fabrics are fabulous–much nicer than typically found in purchased versions.

Sewing expert Pam Hastings has figured out the best way to make each project and to teach the steps to you. Her instructions require only basic sewing skills and very little time. Together we have designed the best coats, boots, collars, costumes, and backpacks any dog lover could sew.

From time to time, I mention my own dog, Scout, so I'd like to introduce you. He is a bichon frise and an ace product tester. Who knew the little devil would change my world once he landed in it? Well, anyone who has ever lived with and loved a dog would understand.

Jennifer Quasha

ON THE GO

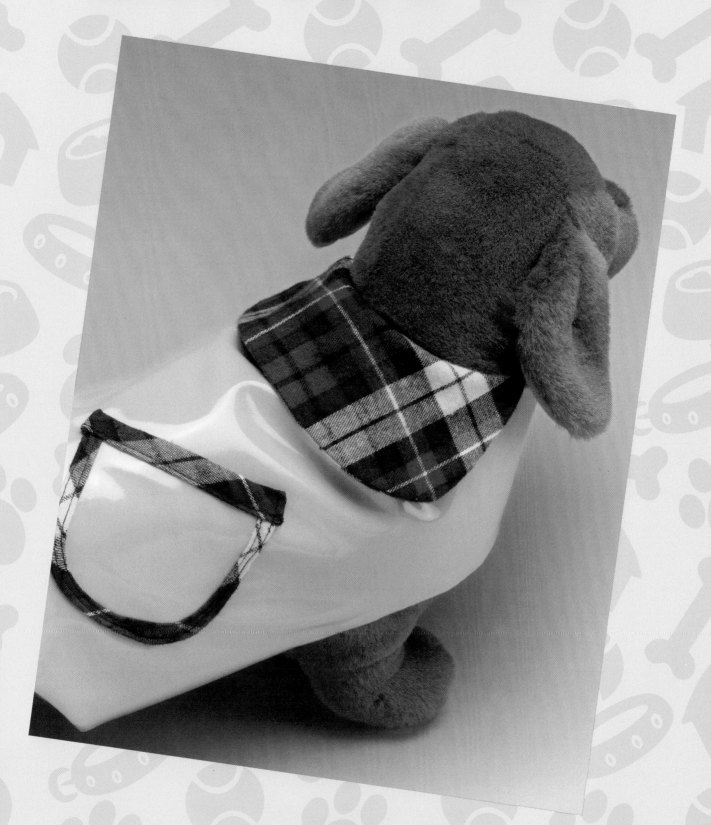

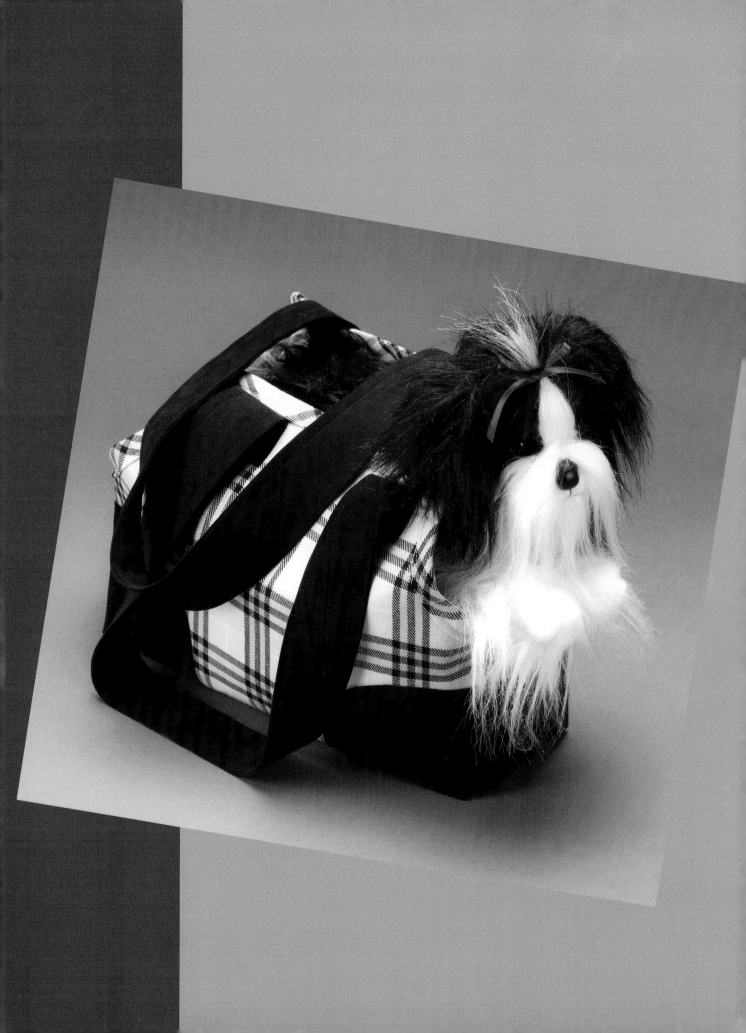

Top Dog
TOTE

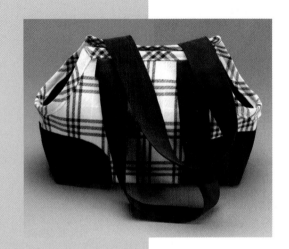

Seen on the streets of New York and other fashion-forward towns: Chihuahuas and Shih Tzus and Yorkies poking their heads out of canine tote bags. These bags are not only chic, but also practical for people who want to take their small dogs everywhere. In boutiques, though, high-end dog totes can cost hundreds of dollars. This design costs much less, even if you use deluxe materials.

For our bag, we went all out with a yummy pink plaid wool and faux suede straps. Inside, thick, wipe-clean vinyl keeps the sides stiff. A vinyl-covered piece of cardboard keeps the bottom of the carrier flat. Both ends of the carrier have a half-moon cut-out so your dog can see where he's going or where he's been.

Your dog needs to get used to riding in the bag, so carry him around the house first. When you're out and about and your dog sees something attractive, just squeeze the bag a little to hold him inside. There's a short elastic safety strap inside the bag that can be hooked onto the dog's collar, allowing some freedom to stand, sit, or lay down but preventing a dangerous "escape."

You Will Need

Patterns (page 120)

Narrow elastic

Small swivel snap hook

¾ yd. (0.7 m) plaid wool

¾ yd. (0.7 m) vinyl

Fabric marker

¾ yd. (0.7 m) heavyweight fusible interfacing

¼ yd. (0.25 m) faux leather or suede

Bias tape maker, 1" (2.5 cm) wide

Fabric glue stick

Stiff cardboard

Double-sided adhesive tape, ½" (1.3 cm) wide

Basic sewing supplies

1 Enlarge the tote pattern 200%. Measure from the dog's chin to the floor when the dog is standing. Measure the side seam of the tote and adjust along the pattern adjustment line to equal the dog's measurement, if necessary. Cut a piece of elastic 2" (5 cm) longer than the measurement. Stitch one end of the elastic to the swivel snap hook and set aside.

2 Cut two tote pieces each from the plaid fabric, vinyl, and interfacing. Mark placement of straps on the right side of the wool. Fuse the interfacing to the wrong side of the plaid fabric, following manufacturer's directions.

3 Trace the pattern for the corner patches, and cut four patches from faux suede. Pin the patches over the lower corners on the right side of the tote. Stitch close to all edges.

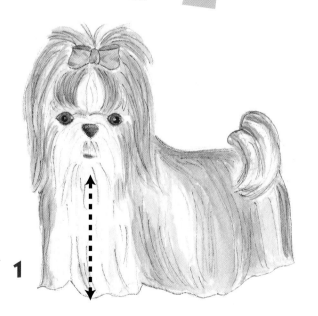

1

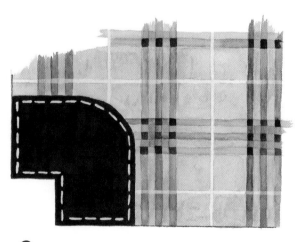

3

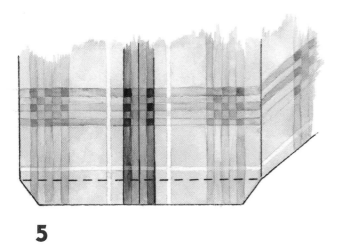

5

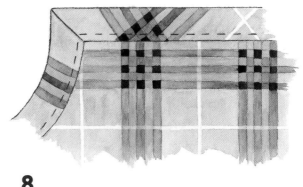

8

4 Pin the tote front and back right sides together. Stitch along the side and bottom edges with a ½" (1.3 cm) seam allowance. Press the seam allowances open.

5 Align the side seams to the bottom seam and stitch across the lower corners of the tote with a ½" (1.3 cm) seam allowance. Turn the tote right side out.

6 Repeat steps 4 and 5 for the vinyl lining, pressing with the fingers only. Catch the free end of the elastic strap in one the bottom corner seams. Place the lining inside the tote, wrong sides together. Machine-baste along the raw edges.

7 Cut a bias strip of fabric 2" (5 cm) wide by 50" (127 cm) long. Make bias tape using the bias tape maker (page 44). Fold the bias tape in half lengthwise, wrong sides together, and press.

8 Wrap the bias tape over the raw edges of the tote, securing temporarily with fabric glue. Miter the corners and ease the binding to fit the curves. Trim off the end, leaving 1" (2.5 cm) excess. Tuck under the raw edge of the overlapping end ½" (1.3 cm). Stitch close to the edge of the binding through all layers.

9 Cut four faux suede straps 1¾" × 26" (4.5 × 66 cm) or to the desired length. Pin two straps wrong sides together. Topstitch close to all edges. Repeat for the other set of straps. Pin the straps in place on the right side of the tote. Topstitch in place.

10 Cut a piece of stiff cardboard to fit the bag bottom. Wrap the cardboard with vinyl, as you would wrap a gift. Secure the vinyl with double-sided adhesive tape. Insert it into the tote.

Out and About
LEASH SET

A deluxe collar and leash can make the perfect statement about your pet. If your dog's name is Daisy, she can wear daisies. Your golden retriever can wear a collar decorated with ducks, pheasants, or whatever is most meaningful to you.

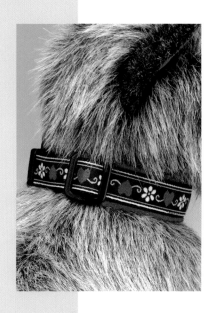

Choose a washable cloth ribbon from the hundreds you'll find at your fabric or craft store. The ribbon is sewn to strong nylon webbing. For sewing through the webbing, use a size 80/12 or 90/14 sharp-pointed needle and always stop with the needle completely down before switching directions. The webbing and hardware are available in many fabric stores and from Internet sources.

To make the set more comfortable than anything you'll find in the stores, a layer of wool felt is placed under the collar. This soft layer is particularly nice for short-haired breeds whose necks can be chafed by normal collars. To make the felt extra cushiony, we washed and dried it before cutting. Once the felt is on the collar, you'll be able to make the collar larger but not smaller, so keep this in mind when sizing it.

There is also felt on the leash handle, so when you are walking your dog–who never pulls, right?–your hand doesn't become chafed either. You can both go out and about in style and comfort.

You Will Need

For a 6' (1.85 m) leash and a 12" to 16" (30.5 to 40.5 cm) collar

2 yd. (1.85 m) wool felt

3 yd. (2.75 m) nylon webbing, ¾" (2 cm) wide

Candle

Rotary cutter with zigzag or scallop blade and cutting mat

3 yd. (2.75 m) ribbon, ⅝" (1.5 cm) wide

Basting tape

Swivel snap hook for leash, with 1" (2.5 cm) slot

Plastic adjustment slide for collar, 1" (2.5 cm) wide

Plastic, side-release, two-piece buckle for collar, 1" (2.5 cm) wide

D ring for collar, 1" (2.5 cm) wide

Fabric glue

Basic sewing supplies

Technique:
Sealing Nylon Webbing

Melting the cut ends of nylon webbing is the quickest, most secure way to keep them from fraying. Just keep a candle in your sewing room and light it when you are working with webbing. Hold the cut end of the webbing to the side of the candle flame and move it slowly back and forth until the fibers have melted together. Seal both ends of each piece right after they are cut. Allow the sealed webbing to cool and harden before you touch it.

LEASH

1 Wash and dry the felt to preshrink it. Cut an 85½" (217.3 cm) length of nylon webbing. Seal the ends by melting them in a candle flame. Cut ribbon to the same length. Cut a strip of felt 1" (2.5 cm) wide and 84" (213.5 cm) long, using a rotary cutter with a zigzag or scallop blade.

2 Center the ribbon on one side of the nylon webbing, using basting tape to hold it in place. Repeat with the felt strip on the reverse side of the nylon webbing. Machine-stitch close to each edge of the ribbon through all layers.

3 Insert one end of the leash through the base of the swivel snap hook; turn back the end 1½" (3.8 cm). Stitch in place to secure.

4 Turn back 6" (15 cm) on the opposite end of the leash to form the handle. Machine-stitch in place.

2

3

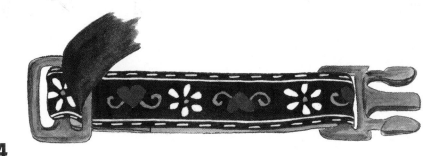

4

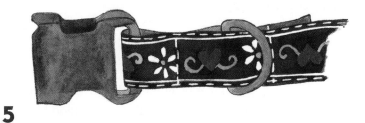

5

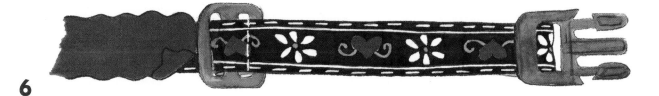

6

COLLAR

1 Measure around the dog's neck. Cut a length of webbing to this measurement plus 6" to 7" (15 to 18 cm). Seal the ends by melting them with a candle flame. Cut a length of ribbon to the same measurement.

2 Center the ribbon on one side of the nylon webbing, using basting tape to hold it in place. Machine-stitch close to each edge of the ribbon.

3 Wrap one end of the collar around the center post of the adjustment slide and stitch in place.

4 Insert the other end of the collar from back to front through the movable buckle part and then back through the adjustable slide.

5 Insert the free end of the collar through the D ring and then from front to back through the stationary buckle part and back onto itself 1½" (3.8 cm). Topstitch through both layers on both sides of the D ring.

6 Try the collar on the dog and adjust it to fit. Cut a 1" (2.5 cm) strip of felt to fit the collar between the adjustable slide and the D ring. Glue the felt strip in place.

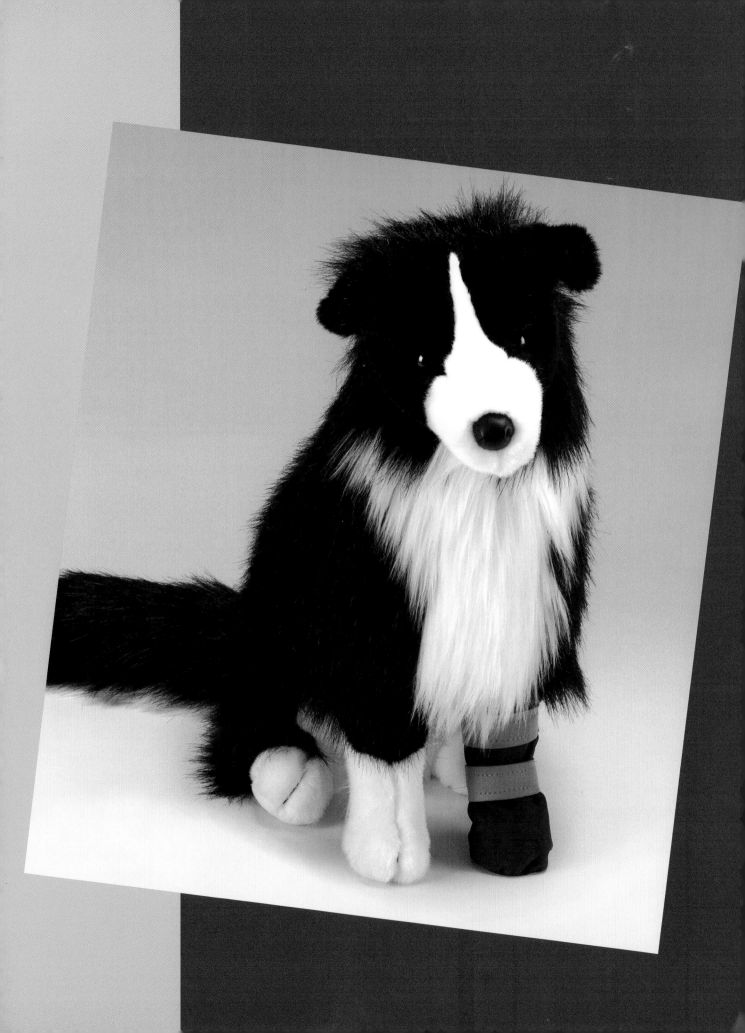

Pup in
BOOTS

Why do dogs need boots? What's wrong with their paws?

Nothing. But on a wet or muddy day, it can be quite a chore to clean your dog's paws. Boots also provide protection from salt on sidewalks and roads. These boots will keep your dog's paws covered when needed.

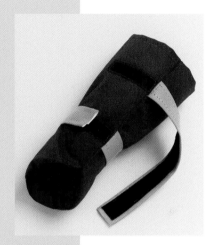

An advantage of making the dog boots is the custom fit. You can also decide how far you want the boots to come up the legs. They don't need to be high unless you have a long-haired dog whose leg fur gets wet or tangled. Consider when you'll use the boots–on long hikes, brief walks, or for protection against wetness or salt.

The boots are made of mediumweight nylon canvas, which can take lots of wear and tear. The straps are made of reflective fabric. In the headlights of a car, they will flicker to life with each step.

These boots will stay on better than ones you could buy, but you do need to put them on correctly. You may think they are too tight, when in fact they must be very tight so they don't fall off.

Your dog will probably need to get used to wearing boots. Start with short stints and lengthen use over time. The first time our dog Scout had boots on, he didn't want his paws to touch the ground. He looked very funny but before long, he got used to them.

You Will Need

Paper and pencil

Patterns (page 117)

Tracing paper for tracing the patterns

⅛ yd. (0.15 m) heavyweight nylon canvas or PVC for boot bottom

¼ yd. (0.25 m) mediumweight nylon canvas

⅛ yd. (0.15 m) reflective fabric

1 yd. (0.92 m) hook and loop tape, ⅝" (1.5 cm) wide

Basting tape

Basic sewing supplies

1 With the dog standing, place a paw on paper. Press down gently with your fingers and trace around the paw, leaving a ¼" (6 mm) margin all around. Then measure from the bottom of the paw to the desired height of the boot. Also measure around the leg, just above the paw and a few inches higher. Give the dog a treat.

2 Cut out the traced paw and compare it to the areas within the stitching lines of the boot bottom patterns, page 117. Choose the pattern that is closest without being smaller. Trace the pattern and cut out four boot bottom pieces. Transfer the pattern markings.

3 Trace and cut out the pattern for the boot that corresponds to the bottom you selected, adjusting the height as needed for your dog. Cut out four boot pieces. Transfer the pattern markings.

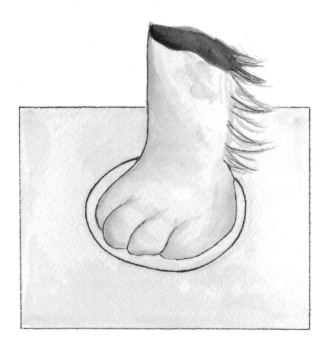

1

5

9

4 Cut eight strips of reflective fabric for the straps 2" (5 cm) wide by the measurement around the leg plus 2" (5 cm). Fold under the long edges of the straps ½" (1.3 cm).

5 Cut eight lengths of loop tape the same length as the straps. Place a length of loop tape on the underside of each strap. Secure with basting tape. Stitch around the loop tape, overlapping the stitches ½" (1.3 cm) where they meet.

6 Cut eight 2" (5 cm) lengths of hook tape. Pin them to the right side of the boots at the marks. Stitch around the edge of each piece, overlapping the stitches where they meet. Place a strap, reflective side down, over each hook tape, aligning the strap end to the raw edge of the boot. Baste across the ends to hold the straps in place.

7 Turn under and stitch a double-fold ¼" (6 mm) hem along the upper edge of each boot.

8 Fold each boot in half, right sides together and raw edges even. Stitch the back leg seam with a ¼" (6 mm) seam allowance stopping at the dot. Finish the seam allowances together with a zigzag stitch.

9 Pin a boot bottom to each boot, right sides together, matching the mark on the boot bottom with the seam. Stitch around the boot bottom with a ¼" (6 mm) seam allowance.

10 Place the dog's paws in the boots. Wrap the straps around the legs very tightly to secure.

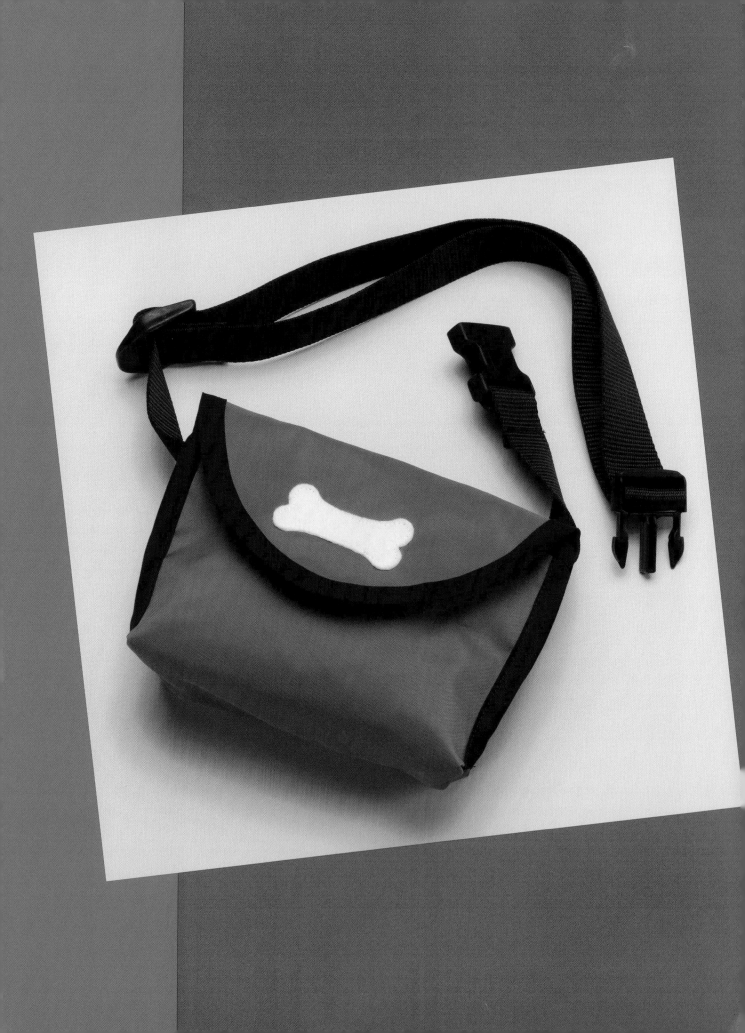

Hideaway
POOP PACK

Have you ever tried to converse with a neighbor or acquaintance while you hold a warm, full baggy? You can feel good about picking up after your dog, but carrying that baggy isn't the best part of walking the dog.

Here's a clever way to solve this problem: the Hideaway Poop Pack. This special fanny pack is made of tough nylon canvas and has room to stow both new and used poop bags, as well as wipes and a small bottle of hand disinfectant. There is a casing on the back for attaching the pack through an adjustable webbed nylon belt so it will fit over your clothes in all seasons. The pack is machine washable, too.

You Will Need

⅓ yd. (0.32 m) mediumweight nylon canvas

Flap template (page 119)

2 yd. (1.85 m) double-fold bias tape

2" (5 cm) strip of hook and loop tape, ¾" (2 cm) wide

Scrap of white felt

Adjustable nylon webbing belt, up to 1½" (3.8 cm) wide

Basic sewing supplies

1 Cut a piece of nylon canvas 9" × 20½" (23 × 52.3 cm) for the center panel. Shape one end for the flap, using the template (page 119). Cut two side panels 3½" × 6" (9 × 15 cm). Cut one belt casing 2½" × 7" (6.5 × 18 cm).

2 Beginning at the end opposite the flap, measure and mark a line on the wrong side of the center panel 6" (15 cm) from the end. Mark a second line 3½" (9 cm) above the first line. Mark a third line 6" (15 cm) above the second line.

3 Turn under the short ends of the casing ½" (1.3 cm) and stitch. Turn under the long edges ¼" (6 mm). Center the casing on the right side of the center panel, just under the third line; pin. Stitch close to the long edges.

4 Pin a side panel to the edge of the center panel, wrong sides together, aligning the ends of the side to the bottom and first marked lines. Machine-baste in place ¼" (6 mm) from the edge. Repeat on the opposite side with the other side panel.

4

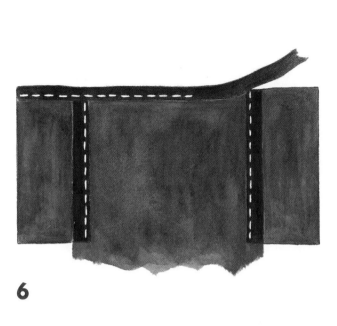

6

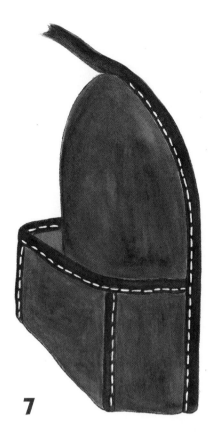

7

5 Cut two 6" (15 cm) strips of bias tape. Pin the bias tapes over the joined raw edges. Stitch close to the inner fold, encasing the raw edges.

6 Turn the side panels and bound edges away from the center. Encase the raw edge in a bias tape strip.

7 Pin the free edges of the side panels to the center panel, wrong sides together, between the second and third marked lines. Machine-baste in place ¼" (6 mm) from the edges. Encase the edges with bias tape, beginning at the bottom of one side panel and continuing around the flap curve to the bottom of the opposite side panel.

8 Turn the pack inside out. Align the side panel bottoms to the open edge of the center panel, right sides together. Stitch ½" (1.3 cm) from the edges. Turn right side out.

9 Stitch the loop tape to the wrong side of the flap, as indicated on the template. Stitch the hook tape to the front of the pack. Cut a small bone from felt, and stitch it in place on the right side of the flap.

10 Insert the belt through the casing.

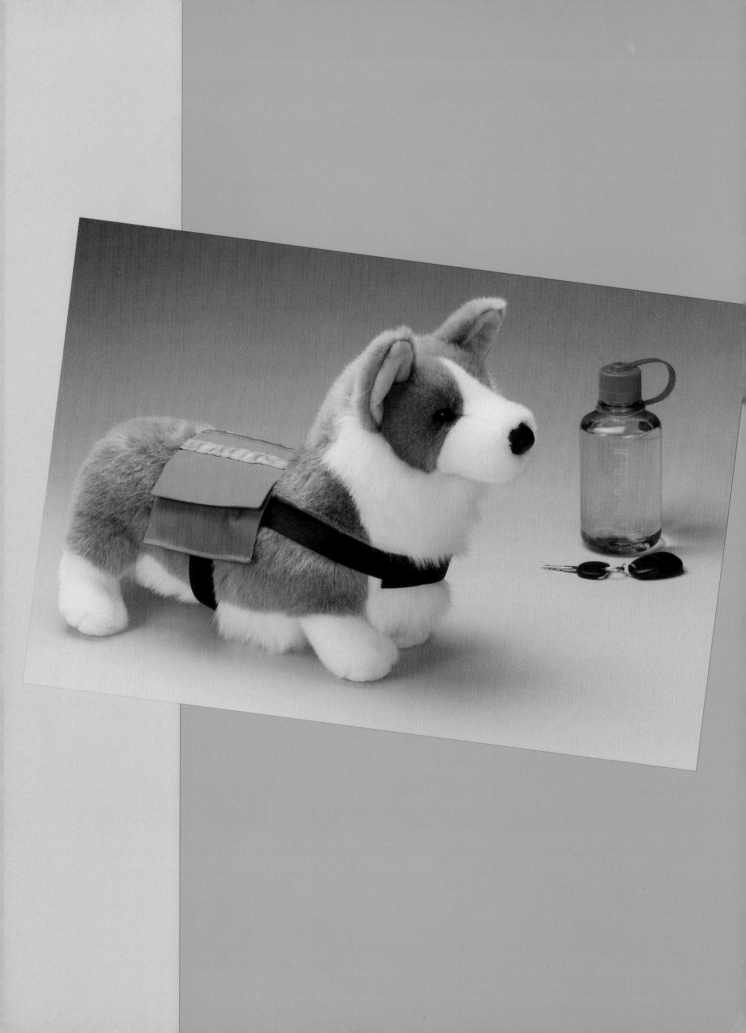

Take a Hike
BACKPACK

On a hike through the woods, your dog probably travels four times as far as you do, running back and forth along the path. Despite how easy it is for the four-legged marvel, you're the one wearing the backpack and holding all the gear. The Take-A-Hike Backpack lets your dog share some of the load.

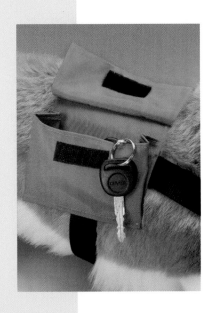

Protect your dog's back by making sure the weight of the backpack falls on the shoulder blades, not on the center of the back. You can adjust the weight of the pack forward by tightening the strap across the front of the chest.

Determine the amount of weight your dog can carry without risking injury. Dogs should carry no more than 20 percent of their body weight. Balance the weight on both sides. Obviously only a big dog will be able to carry a truly helpful amount of gear.

The pack is made of durable nylon canvas and includes reflective stripes for safety.

You Will Need

Nylon canvas (amount determined by measuring the dog)

Nylon webbing (amount determined by measuring the dog)

Candle

8" (20.5 cm) hook and loop tape, ¾" (2 cm) wide

Reflective tape

Basic sewing supplies

1 With the dog standing, measure from the base of the neck to just beyond the shoulders and add 1" (2.5 cm). Measure from the top of one front leg, over the back to the top of the other front leg, and add 1" (2.5 cm). Cut two pieces of nylon canvas (pack and lining) to these measurements. Mark a line across the center of one backpack piece.

2 Cut two pockets the width of the backpack plus 5" (12.7 cm) by one-third of the backpack length plus 1" (2.5 cm). Cut four pocket flaps the width of the backpack plus 1" (2.5 cm) by 4" to 5" (10 to 12.7 cm).

3 Pin the backpack pieces right sides together and stitch around all edges with a ¼" (6 mm) seam allowance, leaving an opening for turning. Turn right side out and topstitch close to the edge.

4 Place the backpack over your dog and mark the placement of the straps in the center of the short (lower) edges and along the front where they will comfortably go around the dog's chest. Cut four nylon webbing straps long enough to overlap 3" (7.5 cm) at the chest front and underside plus 1½" (3.8 cm) for attaching to the backpack. Seal the ends with a candle flame (page 16).

5 Place the straps over the right side of the backpack at the marks, lapping the ends onto the backpack 1½" (3.8 cm). Stitch in a rectangle to secure the straps. Stitch 3" (7.5 cm) strips of hook and loop tape to the strap ends.

5

7

8

9

11

6 Turn under and stitch a double-fold ¼" (6 mm) hem along one long edge of each pocket. Stitch a 1" (2.5 cm) length of hook tape to the center of each pocket front ¾" (2 cm) below the hem.

7 Turn under and press ½" (1.3 cm) on the pocket sides. Turn under and press again 2" (5 cm) on each side, and edgestitch close to the folds.

8 Turn back the inner edge, aligning the folds at the outer edge of the pocket and forming a 1" (2.5 cm) pleat at each side. Press. Baste across the pocket bottom ½" (1.3 cm) from the edge; fold under on the basting line.

9 Pin a pocket to the right side of the backpack, covering the strap ends and aligning the lower edges. Stitch in place close to the lower edge. Then turn back the pleats and stitch the pocket sides in place. Repeat for the other pocket.

10 Stitch a 1" (2.5 cm) piece of loop tape to the right side center of a pocket flap, ¾" (2 cm) from the lower edge. Pin another pocket flap to this one, right sides together. Stitch along the side and bottom edges with a ¼" (6 mm) seam allowance. Turn the flap right side out and press. Repeat with the other two flap pieces.

11 Join the pocket flaps to the pockets at the hook and loop tape. Machine baste the flap tops in place. Cut three strips of reflective tape to fit the width of the backpack. Center one strip over the center line. Stitch in place along all edges. Stitch the other strips over the raw edges of the pocket flaps.

Now You See Me
VEST

When you're walking your dog along a road, this safety vest will ensure that both of you will be seen, day or night. It can also be used for hunting dogs.

Make the vest from blaze orange fabric. (The 3M company now makes an orange fabric that is reflective, too. See sources, page 127.) The vest also has reflective trim. Two black nylon straps with adjustable easy-clasp buckles keep the vest firmly in place. Tighten the straps so they hug the dog, but not too tightly.

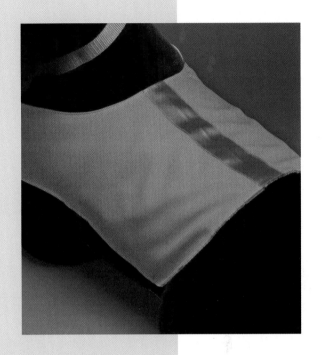

You Will Need

Pattern (page 121)

1 yd. (0.92 m) blaze orange fabric

1 yd. (0.92 m) reflective tape

½ yd. (0.5 m) black nylon webbing,
1" (2.5 cm) wide

Candle

Hook and loop tape

Two adjustable easy-clasp buckles

Basic sewing supplies

Technique:
Reflective Fabric

This easy-care fabric consists of millions of tiny retroreflective lenses bonded to a sturdy cloth. It is flexible and durable and cut edges will not ravel. The fabric can be machine washed in warm water, tumbled dry, and ironed with a medium heat setting. Reflective fabric is sold as precut narrow strips or on bolts up to 36" (91.5 cm) wide. If you can't find it in your local store, shop online using the keyword "reflective fabric."

1 Measure your dog around the neck (A) and from the base of the neck to the desired length of the vest (B). Enlarge the pattern (page 121) as needed to match the dog's measurements. Cut two vest pieces (vest and lining) from orange fabric. Mark the placement lines for the hook and loop tape and reflective strips. Place the vest piece over your dog's back and mark the best place for the under-chest straps.

1

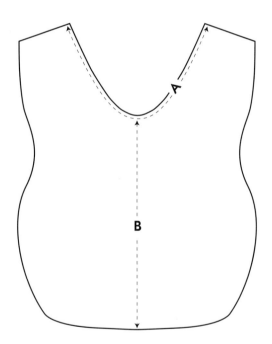

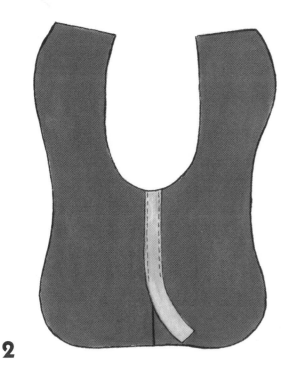

2

5

2 Cut a strip of reflective tape the length of the vest back. Pin the reflective strip to the right side of the vest along the marked line. Topstitch close to each edge.

3 Cut two webbing straps each 4" (10 cm) long. Then cut two more webbing straps, each 10" (25.5 cm) long. Seal the ends by melting them with a candle flame (page 16). Baste the straps to the sides of the vest at the marks with the raw edges even.

4 Pin the vest and lining right sides together. Stitch with a ½" (1.3 cm) seam allowance all around the vest, leaving an opening for turning. Trim the seams to ¼" (6 mm); clip the seam allowances in the curve around the neck. Turn the vest right side out and press with the iron on a low setting.

5 Edgestitch along all edges of the safety vest, closing the opening at the same time.

6 Sew hook and loop tape at the marks as indicated for the front closure.

7 Insert the short straps through the stationary parts of the buckles and stitch in place. Insert the long straps through the slides on the adjustable parts of the buckles.

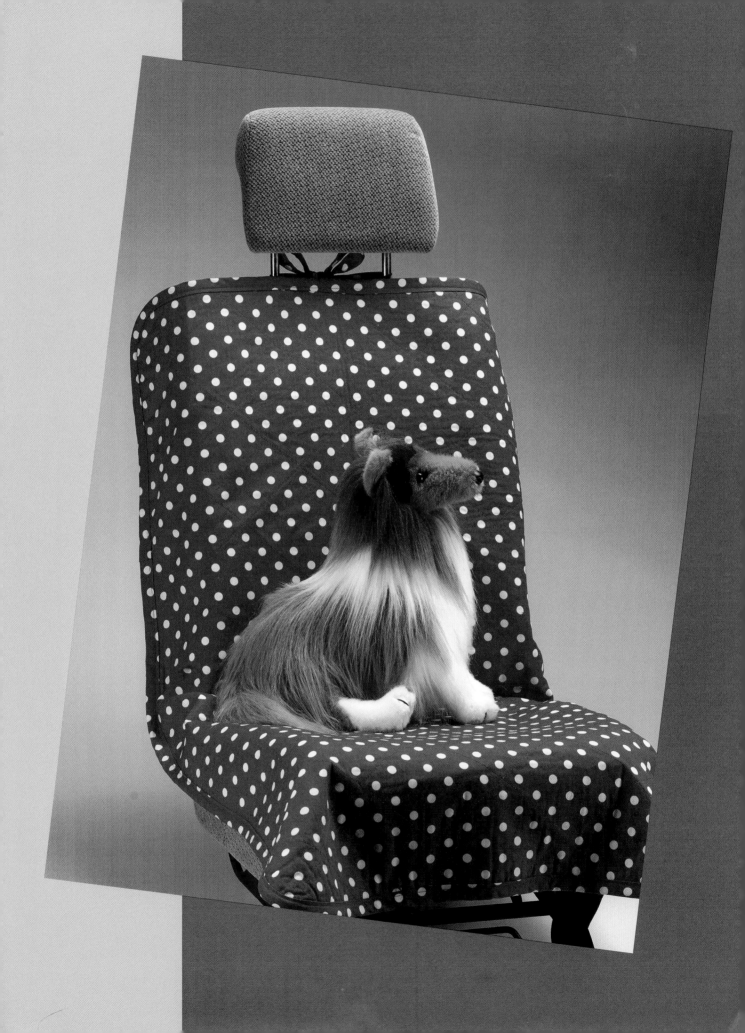

Go for a Ride
SEAT SAVER

Most dogs love to go for rides. Jingle those car keys, and your dog may well be waiting at the door. Afterward, unfortunately, the car seat may be covered with dog hair, paw prints, and wet nose blows–not to mention that odor that seems to seep into the upholstery. You can protect your car seat with this easy cover.

This cover is attached with ties so it fits a bucket seat of any size. One set of ties goes around the headrest, the other around the back of the seat. The cover is lined with terry cloth for extra protection. If your beloved pet likes to find the nearest mud puddle and lie down, consider lining your car seat cover with vinyl.

You Will Need

1⅜ yd. (1.3 m) medium to heavyweight cotton blend fabric for cover

1⅜ yd. (1.3 m) terry cloth for lining

Fabric marker

Round dinner plate

Safety pins

Bias tape maker, 2" (5 cm) wide

Basic sewing supplies

1 Cut a 48" × 27" (122 × 68.5 cm) rectangle of fabric for the outer cover. Cut a matching rectangle of terry cloth for the lining. Cut two 3" × 27" (7.5 × 68.5 cm) fabric strips for the side ties. Cut two 3" × 22" (7.5 × 56 cm) fabric strips for the top ties.

2 Mark rounded corners on the outer fabric, using the edge of a dinner plate as a guide. Cut along the marked lines. Use the outer fabric as a pattern to cut rounded corners on the terry cloth.

3 Mark diagonal lines 4" to 5" (10 to 12.7 cm) apart on the right side of the outer fabric, running in both directions.

2

3

7

8

4 Pin the outer fabric and lining wrong sides together, using safety pins spaced about 8" (20.5 cm) apart. Avoid pinning too close to a marked line. Stitch ⅜" (1 cm) from the edges around the cover. Stitch along all the marked diagonal lines. Remove the pins.

5 Fold a tie in half, wrong sides together, and press. Unfold the tie; turn the raw edges to the center, and press. Fold one end in ½" (1.3 cm) and press. Refold on the center fold line, encasing the raw edges. Stitch close to the outer folds on both long edges and the folded end. Repeat for the other three ties.

6 Pin the short ties, 6" (15 cm) apart, at the center top of the cover on the lining side. Pin the long ties to the sides of the cover on the lining side, at the point where the seat back meets the seat.

7 Cut a bias strip of fabric, 4" × 150" (10 × 381 cm). Piece strips together as necessary. Press the edges to the center to make bias binding, using a bias tape maker (page 44).

8 Open out one edge of the bias binding, and turn under the short end ½" (1.3 cm). Pin the right side of the binding to the lining side of the cover, raw edges even, all around the cover. Clip the binding at the corners to make it lay flat. Lap the opposite end over the folded end ½" (1.3 cm). Stitch in place along the fold line of the binding.

9 Wrap the binding over the raw edges to the front and pin. Edgestitch along the inner fold on the right side.

10 Place the cover over the car seat. Tie the top ties around the headrest posts. Tie the side ties around the seat back.

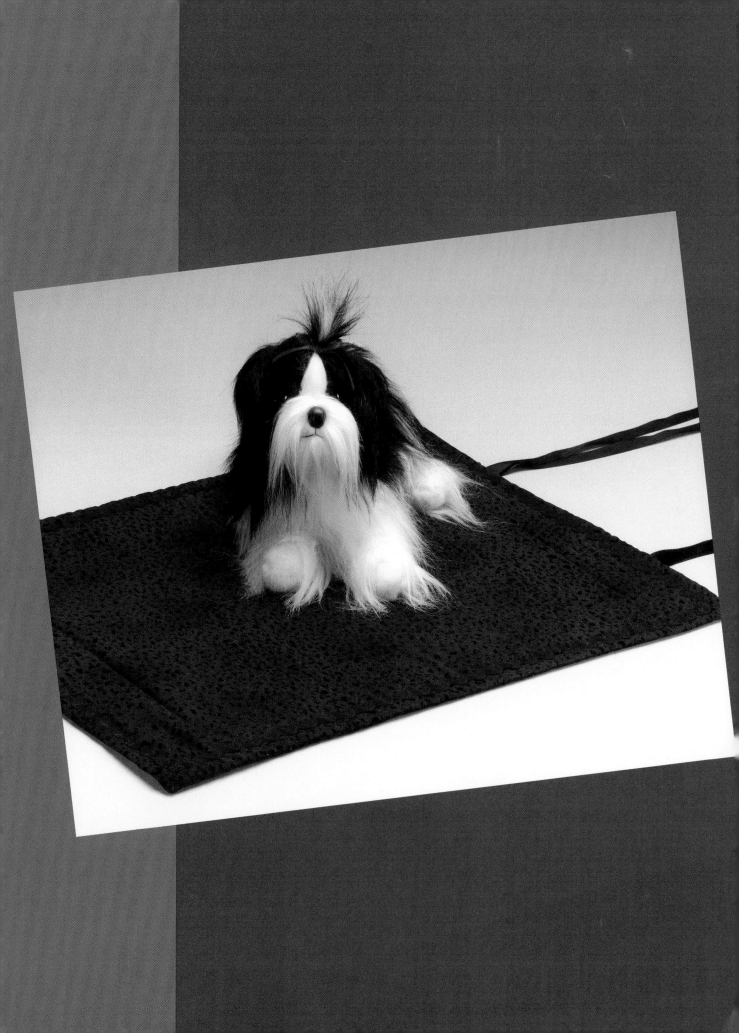

Take Me Along
MAT

Wherever I go, my dog goes. Whether your best friend travels in a crate, bag, or back seat, you can make the surface more comfortable and familiar with this quilted travel mat. Make it to fit your dog's crate or use it alone as a portable dog bed.

The mat rolls up and ties closed, so it's easy to bring along. The cotton velveteen is both plush and machine washable.

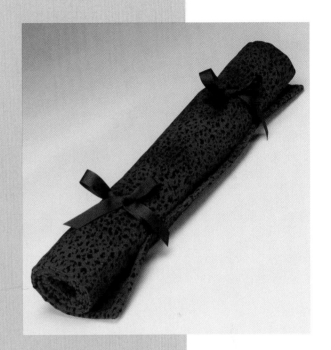

You Will Need

Cotton velveteen (amount determined by size of dog)

Lightweight fusible batting (same amount as velveteen)

1¾ yd. (1.6 m) grosgrain ribbon, 1" (2.5 cm) wide

Rickrack, enough to go around the mat

Fabric glue, optional

Basic sewing supplies

1 Cut two pieces of velveteen to the desired size plus 1" (2.5 cm) in each direction. Cut a layer of batting the same size.

2 Cut two 30" (76 cm) lengths of ribbon. Fold the ribbons in half crosswise, and pin them to the right side of one short edge of the mat, 3" (7.5 cm) from the corners.

3 Fuse the batting to the wrong side of other mat piece, following the manufacturer's directions.

2

4

6

4 Pin the mat front and back, right sides together, and stitch along all edges with a ½" seam allowance; leave an opening for turning.

5 Trim the corners diagonally. Turn the mat right side out and stitch the opening closed. Stitch around the mat ¾" (2 cm) from the outer edges.

6 Mark a line 3" (7.5 cm) from the sides of the mat. Pin the layers together along the line. Stitch along the marked line to quilt the mat.

7 Glue or stitch rickrack along the edges of the travel mat over the stitching line.

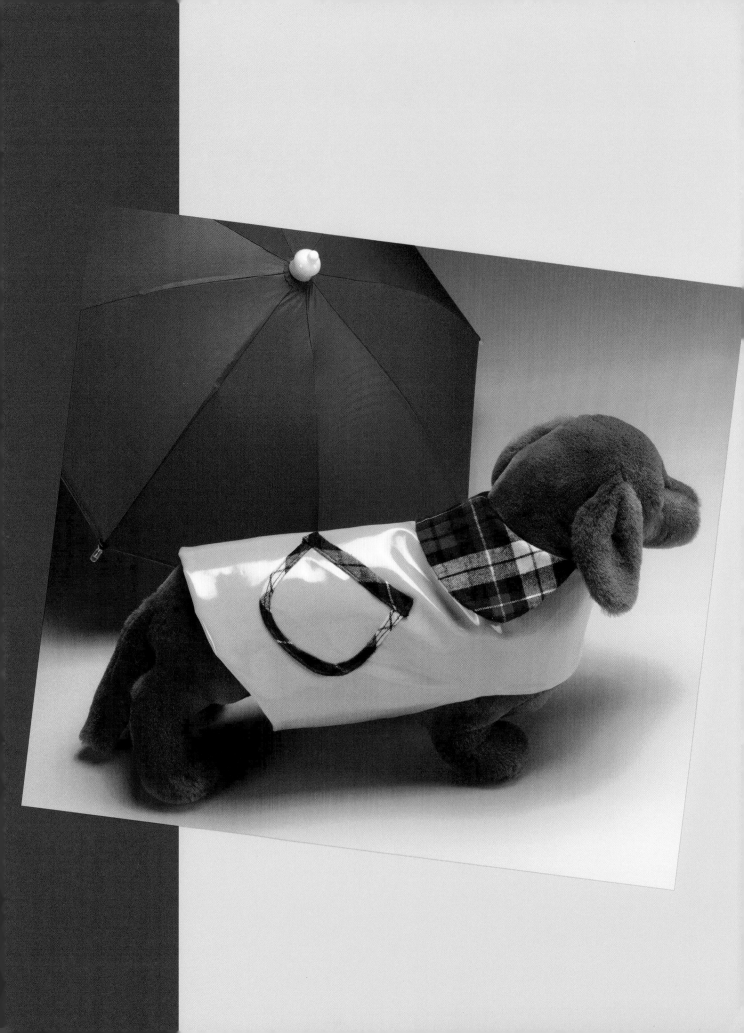

Dry as a Bone
SLICKER

With this coat, you'll have less dog to dry off when you come back from a walk in the rain.

One of the best reasons to make a coat for your dog is so you can be sure the coat fits correctly. See page 48 for tips on measuring your dog and adjusting the pattern. This coat is easy to put on and take off because it closes with hook and loop tape. This beats trying to match a button to a buttonhole under long fur!

We styled the coat in the traditional raincoat look of bright yellow vinyl. For warmth, there is a plaid flannel lining; for even more warmth, you can line the coat with faux shearling.

You may wonder why there's no rain hat. Most dogs hate wearing a hat when they are outside. (They may be less bothered by a costume hat worn inside for a short time.) This is because dogs who are outside want to know what's going on around them, and a hat can block vision and hinder hearing.

You Will Need

Pattern (page 115 and 116)

Yellow vinyl (amount determined after measuring the dog)

Plaid flannel (same amount as vinyl)

Hook and loop tape, ¾" (2 cm) wide

Bias tape maker, ¾" (2 cm) wide

Fabric glue stick

Basic sewing supplies

Technique:
Bias Tape Maker

This tool helps you make custom bias tape for binding the edges of items. Fabric strips are cut on the bias, or diagonal direction, which offers more flexibility for shaping around curves. When a strip is fed through the bias tape maker, the tool folds in the edges evenly so you can press them in place with an iron. Bias tape makers are available in several widths, from ¼" to 3" (6 mm to 7.5 cm).

1 See page 48 for details on measuring your dog. Enlarge the pattern (page 116) and adjust the proportions as needed to match the dog's measurements. Add ½" (1.3 cm) seam allowances all around. Cut out one slicker from vinyl and one from flannel. Transfer the center mark at the neck edge and placement lines for the pocket and hook and loop tape closures.

2 Trace the collar pattern (page 115) and cut two collar pieces from flannel. Transfer the center mark at the neck edge. Pin the collar pieces right sides together and stitch the outer edge with a ½" (1.3 cm) seam allowance; leave the neck edge open. Stitch again just outside the first stitching line. Trim the seam allowances close to the stitching. Turn the collar right side out and press.

3 Pin the collar to the right side of the vinyl slicker neck edge, matching centers. Machine-baste. Pin the lining to the slicker, right sides together. Stitch the outer edge with a ½" (1.3 cm) seam allowance. Leave one front edge open for turning. Stitch again just outside the first stitching line. Trim the seam allowances close to the stitching. Turn the slicker right side out and press gently from the lining side.

2

5

6

9

4 Turn in the seam allowances at the open front edge. Place a strip of loop tape on the lining side, near the front edge, using glue to hold it temporarily. Stitch close to the outer edges of the tape, securing the loop tape and closing the opening at the same time. Stitch hook tape to the right side of the other front edge. Stitch hook and loop tapes to the under-chest closure at the marks.

5 Cut a bias strip of flannel 1½" (3.8 cm) wide and 15" (38 cm) long. Feed the strip through the bias tape maker, pressing the folds in place. Fold the bias tape in half lengthwise, wrong sides together, and press.

6 Unfold the tape. Align one raw edge to the outer edge of the pocket, right side of the tape to the wrong side of the pocket. Machine-baste the bias tape to the pocket, stitching in the first fold line.

7 Wrap the bias tape over the pocket edge to the right side, just covering the stitching line. Secure in place temporarily with glue. Stitch the tape in place close to the fold.

8 Cut a strip of bias tape 1" (2.5 cm) longer than the upper edge of the pocket. Unfold the tape and turn the ends under ½" (1.3 cm). Repeat steps 6 and 7 to bind the upper edge of the pocket.

9 Apply fabric glue to the bound sides and bottom of the pocket. Position the pocket on the slicker. Stitch close to the outer edges of the pocket sides and bottom.

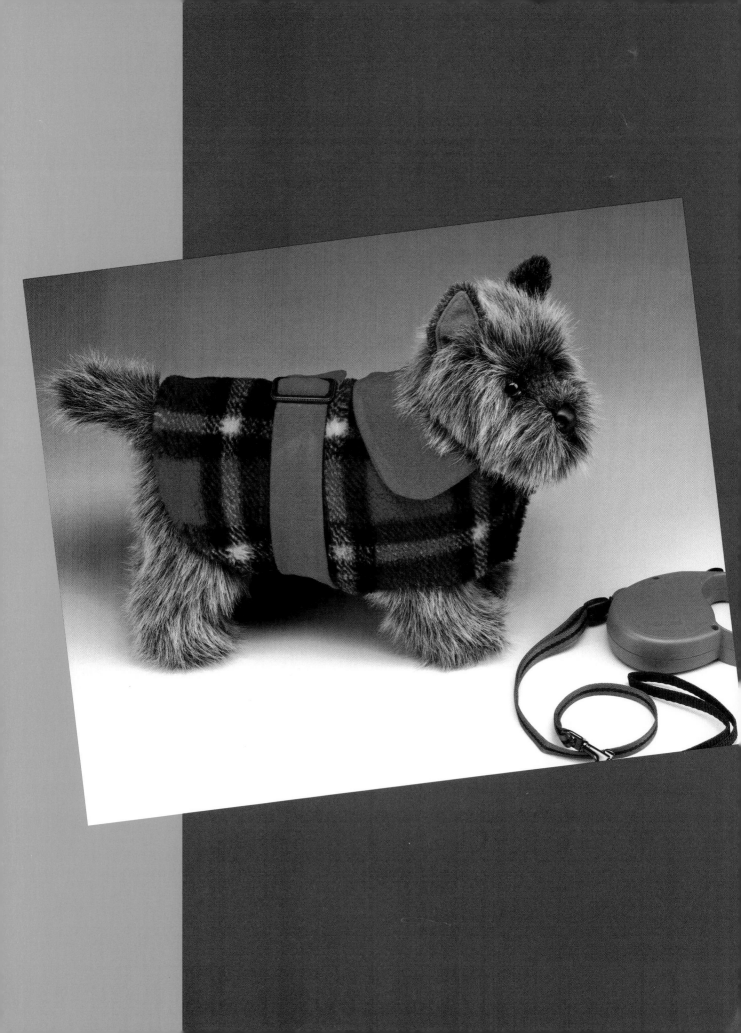

Fleece Fits-Me COAT

What could be better than snuggling into a warm fleece jacket when it's cold? So why not indulge and pamper your pet? Unlike a coat you could buy in a store, this one will actually fit your dog. I have a friend with a basset hound who assures me that there is not a single over-the-counter coat made for a basset's body.

Some people might wonder whether dogs need coats. Although some dogs are comfortable in cold temperatures, many dogs live in places with a climate far different from that where the breed originated. Today there are whippets in Wisconsin and Samoyeds in Savannah. Just as you wouldn't leave a Samoyed in the scorching sun, you should give whippets a little extra warmth in winter, even for a quick walk. Consider also that your dog will not stay as warm at your walking pace as he would if running fast. Besides, wouldn't your dog look fabulous wearing this coat?

To be warm, a coat needs a snug fit, so measure carefully. This coat is fully lined with even more fleece so it's extra warm. The belt and buckle are decorative and can be omitted if you want to make a reversible coat.

You Will Need

Patterns (page 115 and 116)

Plaid fleece for outer fabric (amount determined after drawing pattern)

Solid fleece or flannel for belt, collar, and lining (amount determined after making pattern)

1½" (3.8 cm) buckle

Fusible web tape, ½" (1.3 cm) wide

5" (12.7 cm) hook and loop tape, ¾" (2 cm) wide

Basic sewing supplies

Technique:
Measuring Your Dog for a Custom Coat

Measure your dog from the base of the neck to the base of the tail (A), around the chest behind the front legs (B), from just behind the front of the legs across the front of the chest (C), and around the neck (D). Using the pattern on page 116 as a general guide for shape, draw a custom pattern that fits your dog's measurements. If you have a male dog, position the underbelly closure so it won't get in the way when he needs to do his business.

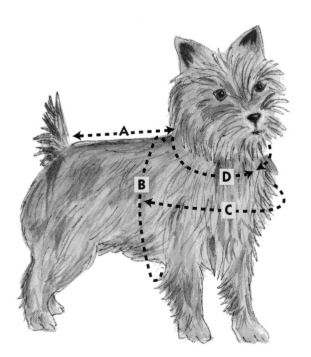

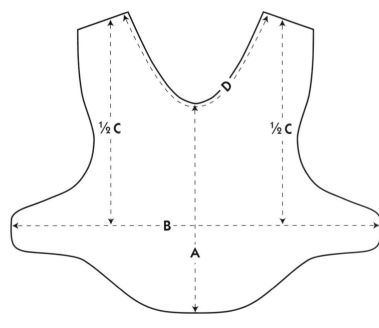

2

3

5

6

1. Enlarge the pattern (page 116) and adjust the proportions as needed to match the dog's measurements. Add ½" (1.3 cm) seam allowances all around. Cut out one coat from each fabric. Transfer the center mark at the neck edge and the placement lines for the belt and closures.

2. Trace the collar pattern (page 115), and cut two collar pieces from flannel. Transfer the center mark at the neck edge. Pin the collar pieces right sides together and stitch around the outer edge with a ½" (1.3 cm) seam allowance; leave the neck edge open. Trim the seam allowances close to the stitching. Turn the collar right side out and press lightly.

3. Pin the collar to the right side of the outer coat, matching centers, and machine-baste in place along the neck edge.

4. For the belt, cut two strips of fabric 4½" (11.5 cm) wide. Cut one of the strips half the chest measurement (B) plus 1" (2.5 cm); cut the other strip half the chest measurement plus 4" (10 cm). Fold each strip in half lengthwise with right sides together. Stitch along the raw edge with a ½" (1.3 cm) seam allowance. Center the seams and press the seam allowances open.

5. At the end of one belt piece, mark a diagonal line from the corner of the fabric to the opposite folded edge. Stitch along the marked line and trim away excess fabric. Turn the belt pieces right side out.

6. Wrap one end of the shorter belt piece over the center post of the buckle and stitch in place. Insert the diagonal end of the other belt through the buckle.

continued

8

7 Position the belt on the right side of the outer fleece from edge to edge, with the buckle in the center of the coat. Secure with fusible web tape. Baste across the belt ends.

8 Pin the coat pieces right sides together and stitch with a ½" (1.3 cm) seam allowance, leaving an opening at one front edge for turning. Trim the seams and turn the coat right side out.

9 Turn the seam allowances of the opening to the inside; pin. Pin a strip of hook tape on the outer coat, near the edge. Stitch around the hook tape, stitching the opening closed at the same time.

10 Stitch loop tape to the lining side of the other front edge. Stitch hook and loop tapes to the chest closure at the marks.

HAUTE DOG

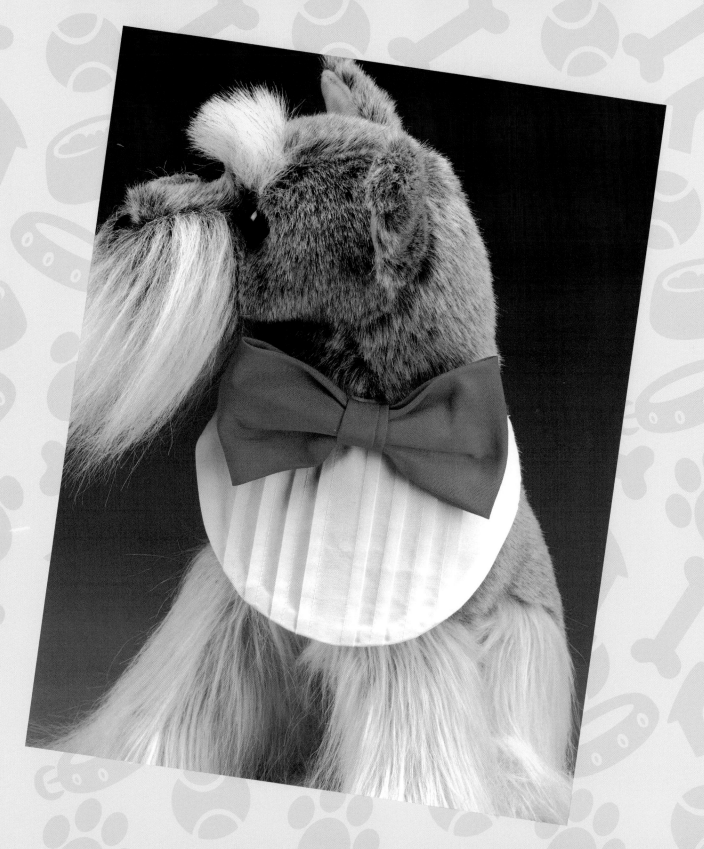

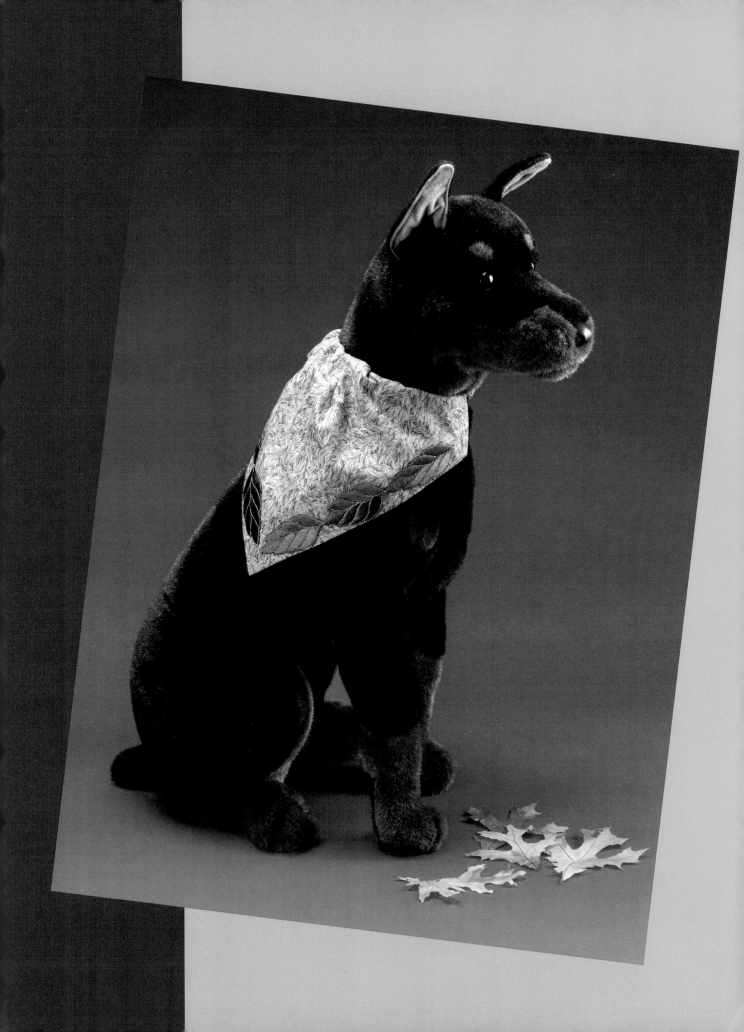

Every Season
BANDANAS

Bandanas are the simplest way to dress up your dog for special occasions. Tying a bandana around a dog's neck isn't the safest idea, though, and some dogs find it irritating. Instead, these bandanas have a casing through which you insert the dog's collar.

The instructions are for one bandana, but you can make your dog a whole bandana wardrobe in no time. Have fun with the cute fabrics and wonderful trims out there! To get you started, here are some styling suggestions for the four seasons of the year.

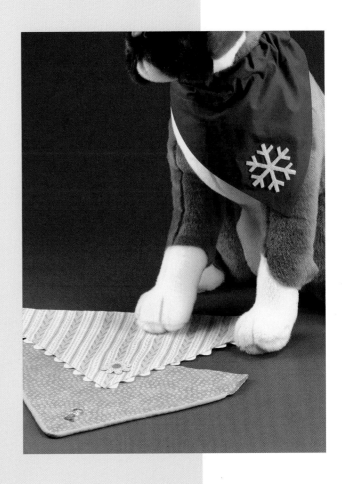

You Will Need

Pattern (page 118)

½ yd. (0.5 m) mediumweight cotton or cotton blend fabric

Appliqué or trim

Fusible web or fabric glue, optional

Basic sewing supplies

1 Enlarge the bandana pattern (page 118), adjusting the size to fit your dog as necessary. Cut one bandana from fabric. Transfer the casing stitching line and dots.

2 Turn under and stitch ¼" (6 mm) double-fold hems on the two short straight sides of the bandana to finish the ends of the casing.

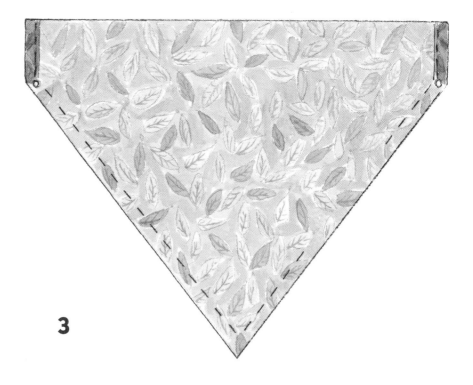

3

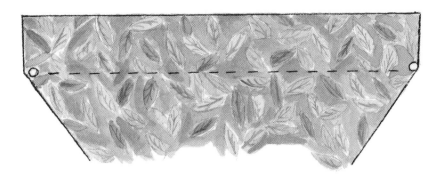

4

3 Fold the bandana in half, right sides together, along the center fold line. Stitch around the bandana between the dots with ¼" (6 mm) seam allowances. Leave an opening for turning along one edge.

4 Turn the bandana right side out and press. Stitch the opening closed. Stitch from dot to dot on the casing stitching line.

5 Fuse, glue, or stitch a seasonal appliqué to the bandana as desired.

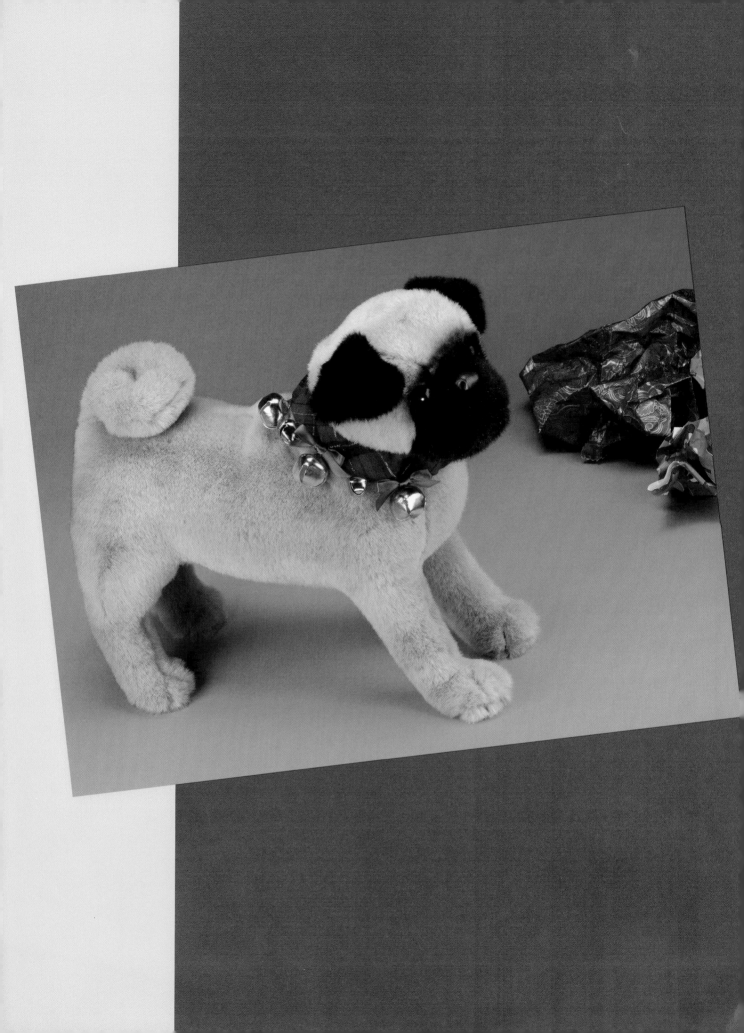

Jingle All the Way
COLLAR

Instead of dressing your dog as Santa this year, consider a musical approach. Your dog might actually enjoy it too.

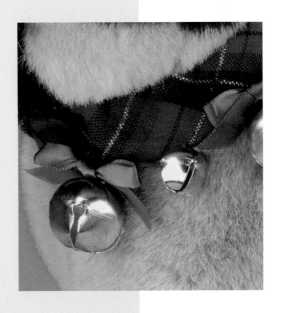

This easy collar is a piece of elastic covered with holiday-plaid cotton with small jingle bells hand-stitched around it. The collar not only looks and sounds festive, but also lets you know if your pooch has climbed into the figgy pudding. (One year, some vigorous ringing led me to find Scout atop the dining room table with his nose in the cookie tray.)

However, when it comes to bells, use restraint. Remember that what is loud to you is even louder for your dog. Not only does she have better hearing than you do, but the bells are only inches from her ears.

You Will Need

½ yd. (0.5 m) lightweight cotton
or cotton blend fabric

¾ yd. (0.7 m) elastic, 1" (2.5 cm) wide

Three large bells

Two small bells

1 yd. (0.92 m) ribbon,
³⁄₁₆" (5 mm) wide

Basic sewing supplies

Technique:
Choosing Elastic

For comfort and stretchability, buy pajama elastic. It is very flexible and soft and has maximum stretch for fitting over your dog's head. Some nonroll elastics are very stiff and don't have nearly as much stretch. Preshrink the elastic by machine washing and drying before sewing it into your project.

1 Measure around the neck at the location of the collar. Cut a 2¾" (4.5 cm) bias strip of fabric the length of the dog's neck measurement plus 6" (15 cm). Fold the fabric in half lengthwise, right sides together. Stitch along the long edge of the strip with a ¼" (6 mm) seam allowance. Turn right side out and press.

2 Cut a length of elastic 2" (5 cm) longer than the dog's neck measurement. Insert the elastic through the fabric tube. Secure into a circle with a straight or zigzag stitch. (See illustration 4 on page 85.)

1

4

3 Overlap the fabric ends, tucking under the raw edges of the upper layer. Stitch in place by hand.

4 Hand-stitch bells to the lower edge of the collar, alternating large and small. Cluster them on one side of the collar so they can be worn to the side or back. Tie small ribbon bows and stitch them above the large bells.

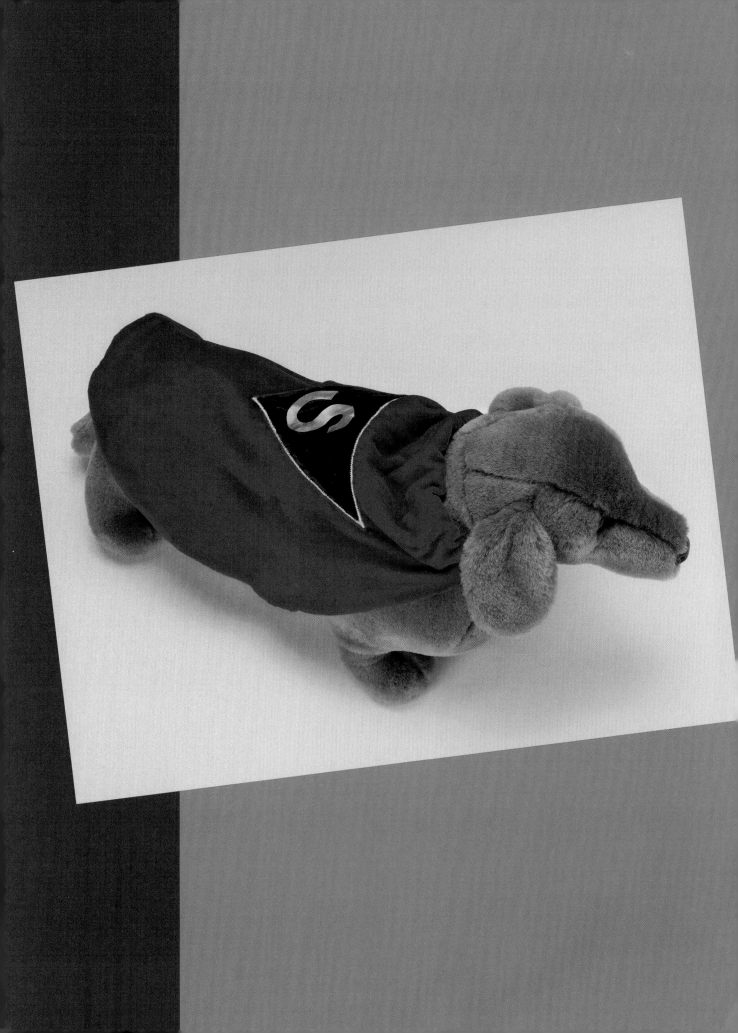

Superdog
CAPE

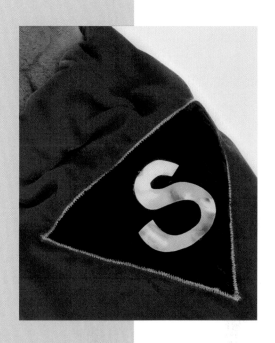

For years we bought Halloween costumes for Scout, and he hated every single one. The elastic bands on the hats were too loose or too tight, and the capes were too long and got caught up in his back legs. Finally, an easy homemade costume solved our problem: The Superdog Cape. This simple cape stays in place without uncomfortable elastic straps. Simply thread your dog's collar through the cape's casing. You can size the cape to fit your dog's frame. You can also pick a fabric–like this regal red velveteen–that's much better than flimsy material made in commercial dog costumes.

Every dog is a superhero, and now yours can dress the part.

You Will Need

Pattern (page 123)

Red velveteen, amount determined after drawing pattern

Lightweight cotton or cotton blend for lining, same amount as for velveteen

6" (15 cm) square blue velveteen

Scrap of gold metallic fabric

Tear-away fabric stabilizer

Gold machine embroidery thread

Fabric glue

Basic sewing supplies

1 Enlarge the pattern (page 123), adjusting the size for your dog as necessary. Cut one cape from velveteen and one from the lining fabric. Mark the stitching lines for the appliqué on the wrong side of the cape. Mark the fold line on the right side of the lining fabric.

2 Place the square of blue velveteen, right side up, over the right side of the cape, centered over the appliqué location. Pin in place from the wrong side of the cape.

Technique:
Tear-away Stabilizer

Placing a piece of tear-away stabilizer under the cape before satin stitching around the appliqué prevents the fabric from puckering or waving, especially when stitching diagonally. Several tear-away stabilizers are available at fabric stores. In a pinch, you can simply use plain white paper. After stitching, the stabilizer easily tears away. Any stabilizer caught under the stitches is harmless, so leave it there.

2

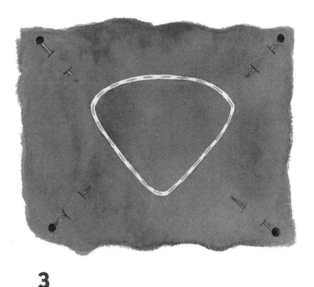

3

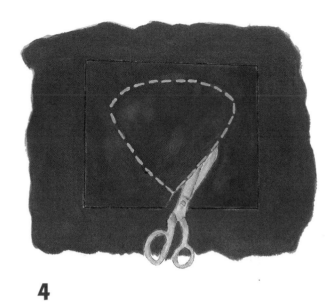

4

3 With the wrong side of the cape facing up, stitch along the marked shield line.

4 On the right side, trim away blue fabric just outside the stitching line.

5 Place a sheet of tear-away stabilizer under the cape behind the shield. Using gold machine embroidery thread, sew a narrow satin stitch around the edges of the shield. Tear away the stabilizer.

6 Cut an "S" from the gold fabric. Secure it in the center of the shield, using fabric glue.

7 Pin the cape and lining right sides together and stitch with a ½" (1.3 cm) seam allowance, leaving an opening in the top for turning. Trim the seam allowances to ¼" (6 mm). Turn the cape right side out, and press lightly from the lining side of the fabric.

8 Fold in the seam allowances of the opening. Fold the top under along the marked fold line. Stitch in place close to the edge, closing the opening and forming a casing for the collar.

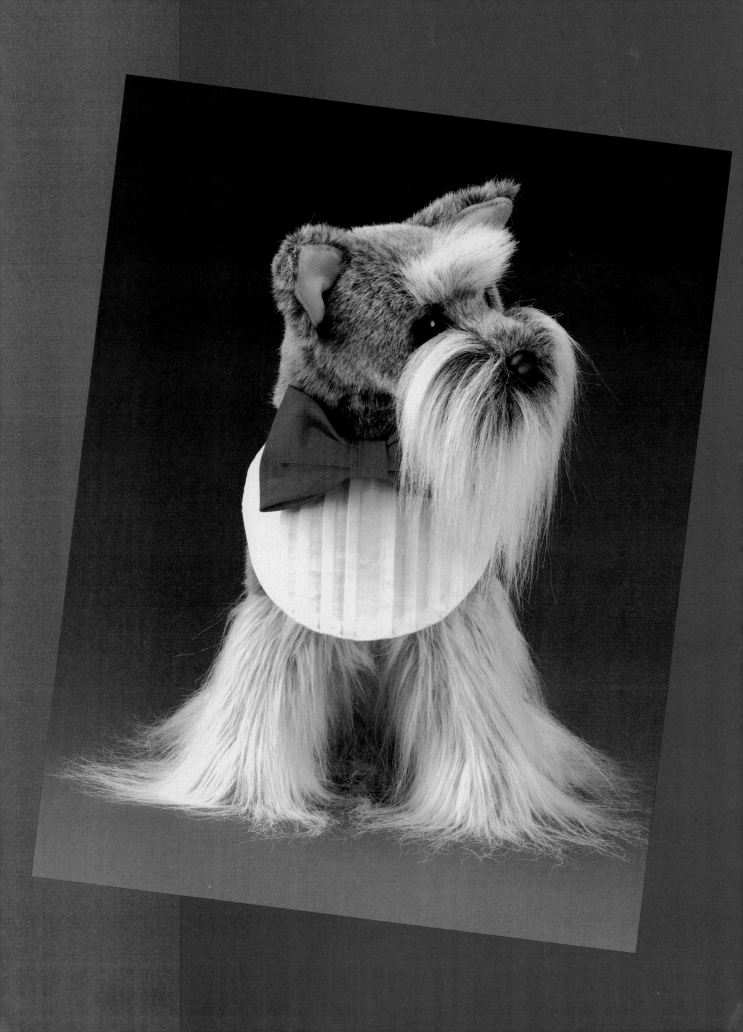

Dog About Town
TUXEDO

A dog never looks more dapper than when he's wearing a tuxedo. And of course a tux is a must for a male dog who is in a wedding party or has other formal obligations. It is also a dignified Halloween costume.

The tux is designed like a bib. It doesn't need elastic around the neck since it is made to measure for your dog. This makes it more comfortable and, as we know, comfort is key if you want your dog to keep special clothes on.

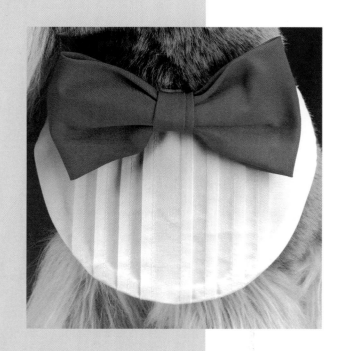

You Will Need

Pattern (page 124)

¼ yd. (0.25 m) white cotton fabric for bib

¼ yd. (0.25 m) taffeta for bow tie and neck straps

2" (5 cm) hook and loop tape, ⅝" (1.5 cm) wide

Basic sewing supplies

1 Trace the patterns (page 124) for the tux and tux lining onto paper. Cut out one of each from white fabric. Mark the placement of the tuck fold lines (solid lines) on the tux front.

2 Fold and press the fabric along the marked lines, one at a time. Stitch ¼" (6 mm) away from each fold. Press the tucks away from the center.

3 Stitch the tux front and lining right sides together with a ¼" (6 mm) seam allowance, leaving one shoulder open for turning. Turn right side out and press. Stitch the opening closed.

2

5

9

4 Cut a 4½" × 10" (11.5 × 25.5 cm) bias strip of fabric for the bow tie and a 2½" × 3" (6.5 × 7.5 cm) strip for the knot. Fold the bow fabric in half lengthwise, right sides together. Stitch along the long edge of the fabric with ¼" (6 mm) seam allowances. Turn right side out, center the seam, and press lightly. Repeat with the knot fabric.

5 Lay the tie facedown on a flat surface. Fold the ends in, overlapping them slightly in the center. Stitch in place through all layers.

6 Wrap the knot around the bow tie, pleating the tie and the knot. Trim away any excess knot fabric and slipstitch the knot in place on the wrong side of the bow tie.

7 Hand-stitch the bow tie to the front of the tux.

8 Hold the tux up to your dog and measure the distance from one shoulder to the other, around the back of his neck. Cut two 2" (5 cm) wide bias strips of fabric for the neck bands, each half of this measurement plus 2½" (6.5 cm). Fold the neck bands in half lengthwise, right sides together, and stitch the long edge and one short end with ¼" (6 mm) seam allowances. Turn the bands right side out and press.

9 Turn in the seam allowances of the open ends and press. Lap the neckbands over the shoulders of the tux and secure in place with zigzag stitches.

10 Stitch a 2" (5 cm) strip of loop tape to the underside end of one neck band. Stitch the hook tape to the right side end of the other band.

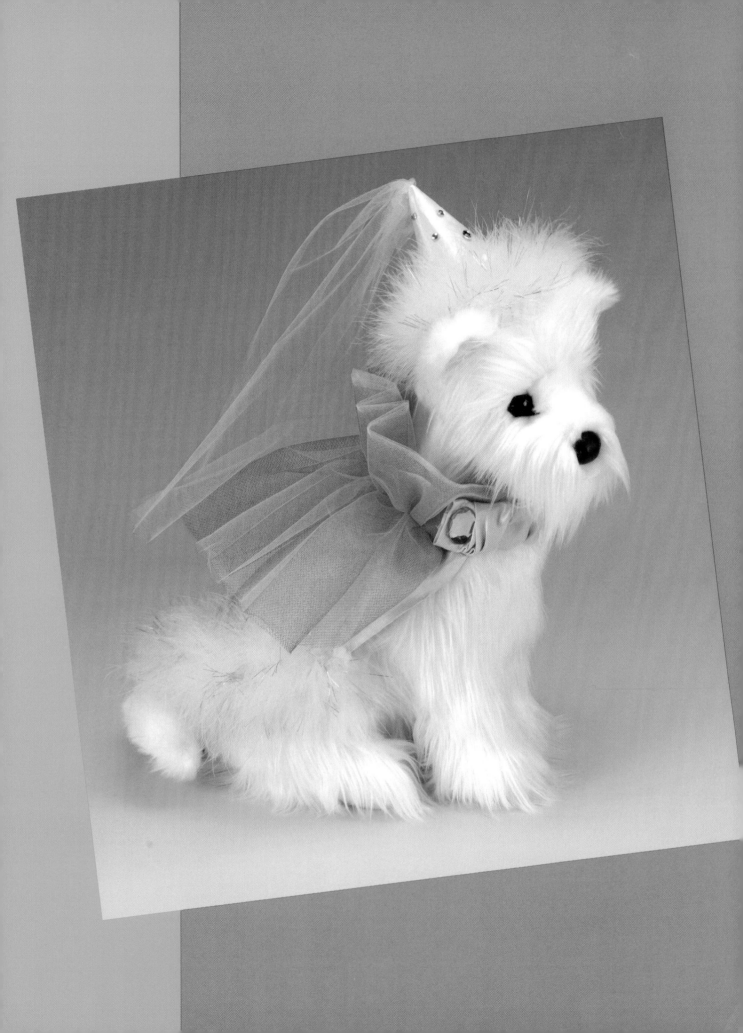

Princess Pooch's
GETUP

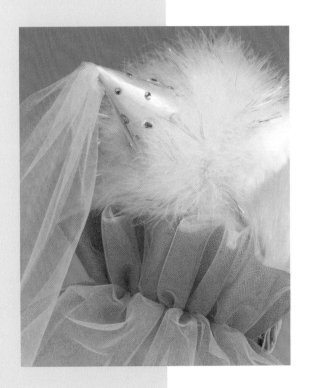

Some people can't resist playing dress-up with their dogs. I know a miniature pinscher who is regularly decked out in leather, a Maltese with as many barrettes as there are colors of crayons, and a Chihuahua who happily wears a blue sombrero.

This princess getup is a fun way to celebrate your dog while keeping the clothing comfortable. The costume is a satin cape dressed up with netting, jewels, and marabou feathers. A hidden casing for the dog's collar helps keep the cape in place. The matching hat is made from the fusible backing used for lamp shades. Make sure to fit the elastic comfortably under your dog's chin, not too loose or too tight, and if she hates wearing it, don't force her. It probably won't stay on for long, but for five minutes you'll have a great photo op.

You Will Need

Patterns for cape and hat (page 123 and 122)

¾ yd. (0.7 m) pink satin

¼ yd. (0.25 m) elastic, 1" (2.5 cm) wide

½ yd. (0.5 m) light pink tulle

½ yd. (0.5 m) hot pink netting

Pearl cotton

1 yd. (0.92 m) marabou feathers

Scrap of hook and loop tape

Two large flat-back jewels

12" (30.5 cm) square of fusible lamp shade backing

Fabric glue or hot glue gun

½ yd. (0.5 m) elastic, ½" (1.3 cm) wide

12 to 15 small flat-back jewels

Basic sewing supplies

CAPE

1 Enlarge the cape pattern (page 123), adjusting the size for your dog. Cut two capes from pink satin. Mark the placement line for the casing on the right side of one fabric piece.

2 Cut a strip of satin for the front neck strap 3½" (9 cm) wide by the dog's neck measurement. Stitch a narrow hem in one short end. Fold the fabric in half lengthwise, right sides together. Stitch with a ½" (1.3 cm) seam allowance. Center the seam and press the seam allowances open. Turn the strap right side out.

3 Cut a length of 1" (2.5 cm) elastic equal to half the dog's neck measurement. Insert the elastic into the front neck strap. Baste across each end, securing the elastic inside the strap.

4 Pin the unhemmed end of the neck strap to the right side of the cape, centered on the casing placement line. Pin the cape pieces right sides together. Stitch around the edge with a ½" (1.3 cm) seam allowance, leaving an opening along the top for turning. Trim the seam allowances, turn right side out, and press.

7

10

5 Cut a strip of fabric for the collar casing 2½" (6.5 cm) wide and the length of the top of the cape minus 1" (2.5 cm). Stitch narrow double-fold hems on the ends. Turn under ½" (1.3 cm) on the long edges and press. Center the casing over the placement line and stitch close to each long edge.

6 Cut two cape pieces from pink tulle and one from hot pink netting. Layer the pieces with the netting on the bottom and two layers of tulle on top. Treating the layers as one fabric, fold the upper edge under 2¼" (6 cm) and finger press.

7 With the netting side up, zigzag over a length of pearl cotton 2" (5 cm) below the fold. Pull up on the pearl cotton to gather the layers.

8 Pin the gathered tulle and netting layers to the right side of the princess cape, aligning the gathering line to the lower stitching line of the casing, with the ends 1" (2.5 cm) from the cape sides. Stitch in place along the gathering line.

9 Hand-stitch or glue marabou feathers along the bottom curved edge of the cape.

10 Sew a small piece of loop tape to the wrong side of the free end of the neck strap. Stitch the matching hook tape to the right side of the cape.

11 Glue one large jewel to the right side of the free end of the neck strap. Glue the other one to the cape at the fixed end of the strap.

12 Insert the dog's collar through the casing and place the collar on the dog. Secure the front neck strap.

continued

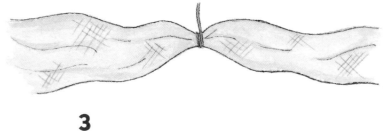

1

2

3

HAT

1 Fuse the shade backing to the wrong side of a square of satin. Trace the hat pattern (page 122) onto paper and cut out. Cut a hat from the stiffened satin. Overlap the straight edges and glue in place.

2 Stitch one end of the elastic inside the hat. Place the hat on the dog to measure for the correct length of the elastic. Trim away excess elastic and stitch the other end inside the hat.

3 Cut two 1" × 12" (2.5 × 30.5 cm) strips of tulle. Tie the strips together at the center. Handstitch or glue them to the point of the hat.

4 Glue small jewels randomly over the hat; glue the marabou feathers around the lower edge.

AT HOME

Chinny Chin
CHIN REST

Dogs love to rest their chins—

on people's laps, on their feet, on a shoe left on the floor, on the arm of a chair. Now you can make your dog a chin rest that will be available whenever and wherever he wants to rest his weary head. Dogs like to carry this pillow from room to room.

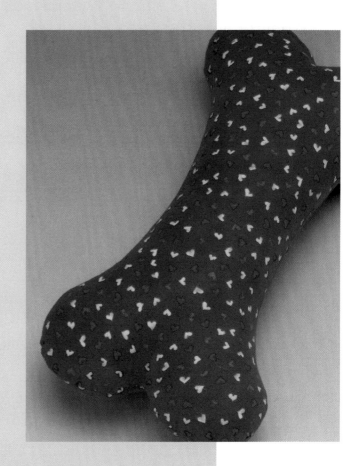

You Will Need

Pattern (page 122)

⅜ yd. (0.35 m) flannel

Polyester fiberfill

Basic sewing supplies

1 Trace the bone-shaped pillow pattern onto paper. Cut out two pillow pieces, placing the pattern on the fold as indicated.

2 Pin the pieces right sides together. Stitch around the outer edge with ¼" (6 mm) seam allowance, leaving an opening for turning.

Technique:
Polyester Fiberfill

This billowy stuffing is sold in a clear plastic bag. Pull out small amounts of fluff and push them into the chin rest through the opening in the seam. Use the handle of a wooden spoon to force the filling into the ends, filling the pillow to a plump medium firmness. Both fabric and filling are completely machine washable if you can get your dog to part with his chin rest for a short time.

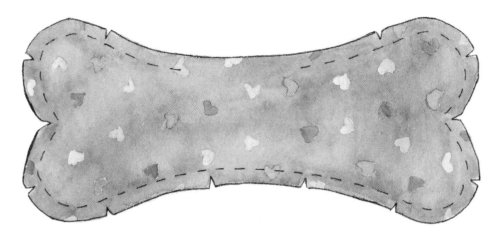

3

4

3 Clip into the corners and on inner curves to within ⅛" (3 mm) of the stitches. Turn the pillow right side out and press.

4 Stuff the pillow firmly with fiberfill. Slipstitch the opening closed.

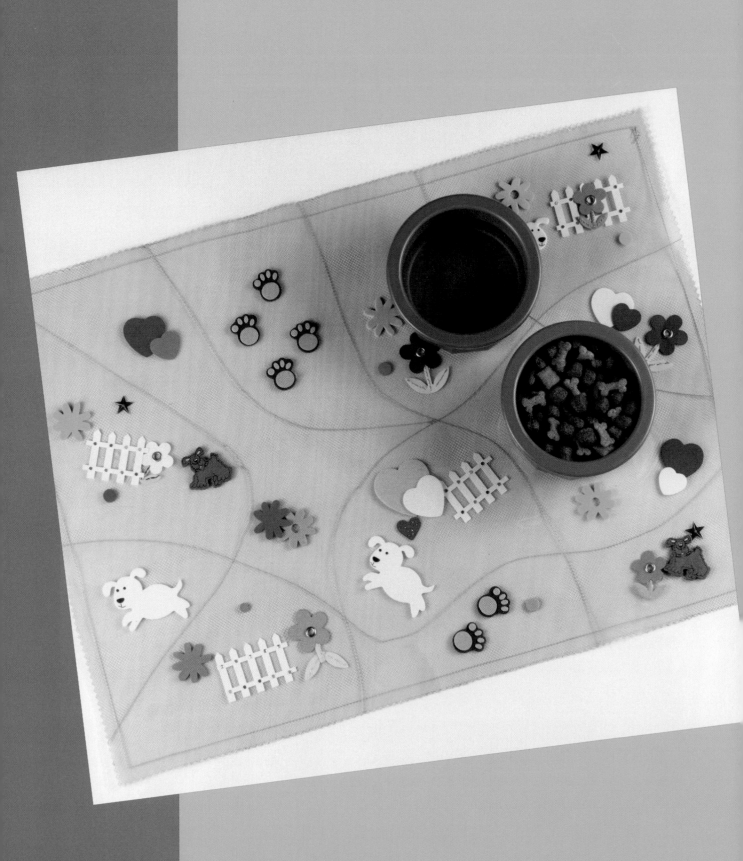

Kibble Dribbles
PLACEMAT

Protect your floor from kibble and dribbles with this fun place mat. The mat makes clean-up easier, too, because you can pick it up and take it to the sink for washing.

The placemat has clear vinyl covers with decorative shapes and colorful netting sandwiched in between. The vinyl is available in fabric stores. Craft stores sell cute foam and paper cutouts. If you like, add some glitter or sequins. However, I would avoid using real dog treats. I know many a dog who would make short work of two sheets of vinyl to get at a tasty treat.

You Will Need

½ yd. (0.5 m) 10- or 12-gauge vinyl

½ yd. (0.5 m) colored netting

Permanent marker

Spray adhesive

Decorative foam or paper shapes

Tissue paper

Silicone lubricant

Pinking shears

Basic sewing supplies

Technique:
Stitching on Vinyl

For ease in stitching on vinyl, use a size 90/14 needle and a long stitch length. Apply silicone lubricant, available where sewing notions are sold, to the vinyl ahead of the presser foot, and place a sheet of tissue paper under the vinyl to prevent drag as you stitch.

1 Cut two 18" × 24" (46 × 61 cm) pieces of vinyl and two 18" × 24" pieces of netting. Mark a line with permanent marker ¾" (2 cm) from each edge of one of the vinyl pieces.

2 Place one piece of netting over a protected surface and spray lightly with adhesive. Place the shapes on the netting at least 1" (2.5 cm) from the edges.

3

5

3 Position the marked vinyl piece over the netting and press in place. Lift the vinyl and netting and place them over the other netting and vinyl pieces. Remove any large air pockets. Pin the layers together outside the marked line.

4 Place tissue paper under the placemat. Stitch around the placemat ¼" (6 mm) inside the marked line, using silicone lubricant (left) to prevent drag.

5 Stitch random lines across the placemat.

6 Tear away the tissue paper. Using pinking shears, trim around all edges of the placemat just inside the marked line.

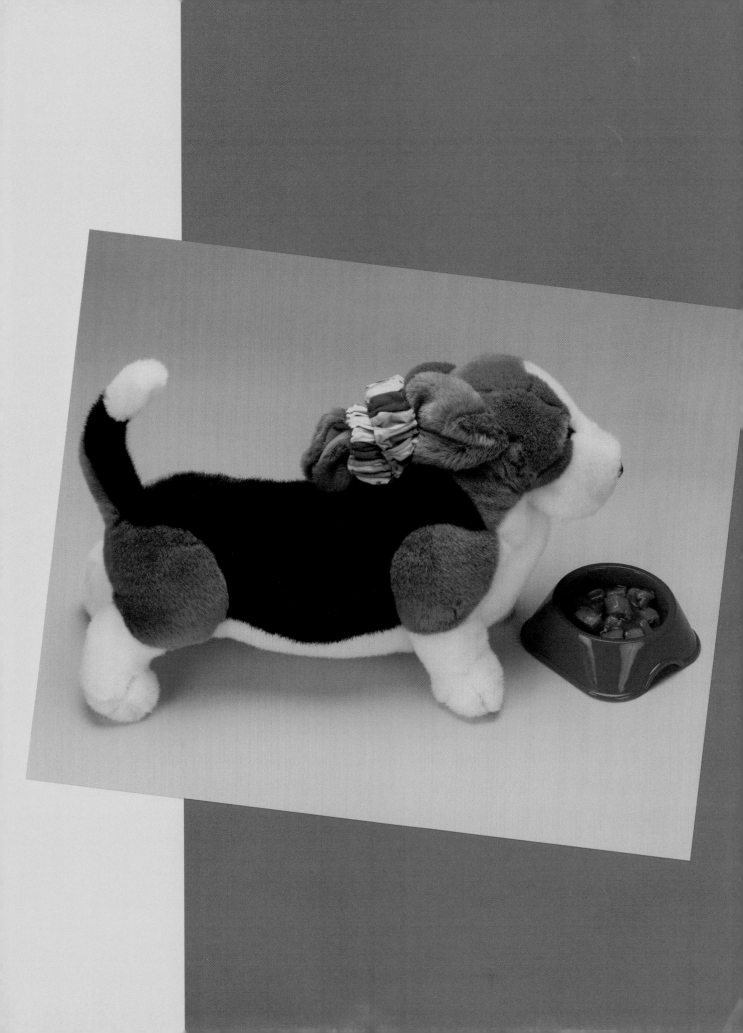

Clean Ears
SCRUNCHIE

Long ears seem to have a way of always landing in a dog's food dish. If you have a basset hound or cocker spaniel, you may be tired of washing ears after every meal. Here's an easy way to keep ears up and out of the way. This "ear protector" is a fabric-covered elastic band that slips over the head and holds the ears back. There are various ways to put it on, depending on the dog. Try the position shown here, holding the ears behind the head like a pony tail. The scrunchie also could go over the ears and around the dog's neck like a collar.

Making the scrunchie to fit your dog ensures that you can get the size right. It might take a little while for your dog to get used to wearing it, but reward training using food or treats can speed the process along.

The ear scrunchie is easy to make. You can use almost any fabric, but stay away from scratchy material that might irritate. We chose a soft and fluffy colorful flannel.

You Will Need

⅛ yd. (0.15 m) fabric

Elastic, 1" (2.5 cm) wide, length determined after measuring the dog

Basic sewing supplies

1 Measure around your dog's head or ears in the position you intend to place the scrunchie. Cut a strip of fabric twice this length by 4" (10 cm) wide. Cut a length of elastic to the measured length, plus 2" (5 cm).

2 Fold the fabric strip in half lengthwise, right sides together. Stitch along the long edge with a ½" (1.3 cm) seam allowance. Press the seam allowances open.

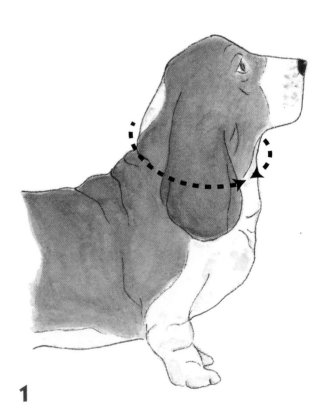

1

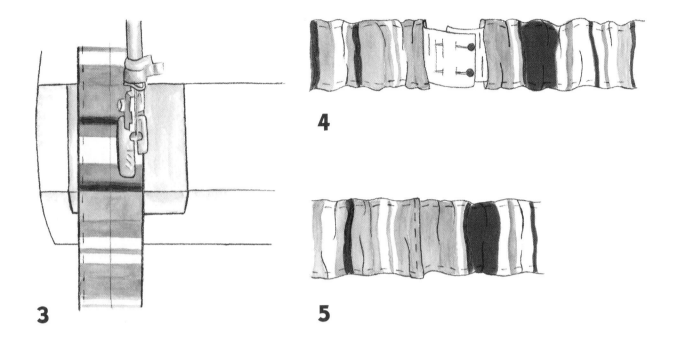

4

3

5

3 Turn the tube right side out, centering the seam. Turn in the raw edges at one end. Edgestitch close to each side of the tube.

4 Insert the elastic through the tube. Overlap the edges of the elastic by 1" (2.5 cm) and pin in place. Stitch through the elastic with a zigzag stitch to secure.

5 Lap the finished end of the tube ½" (1.3 cm) over the other end. Straight stitch through all layers across the scrunchie.

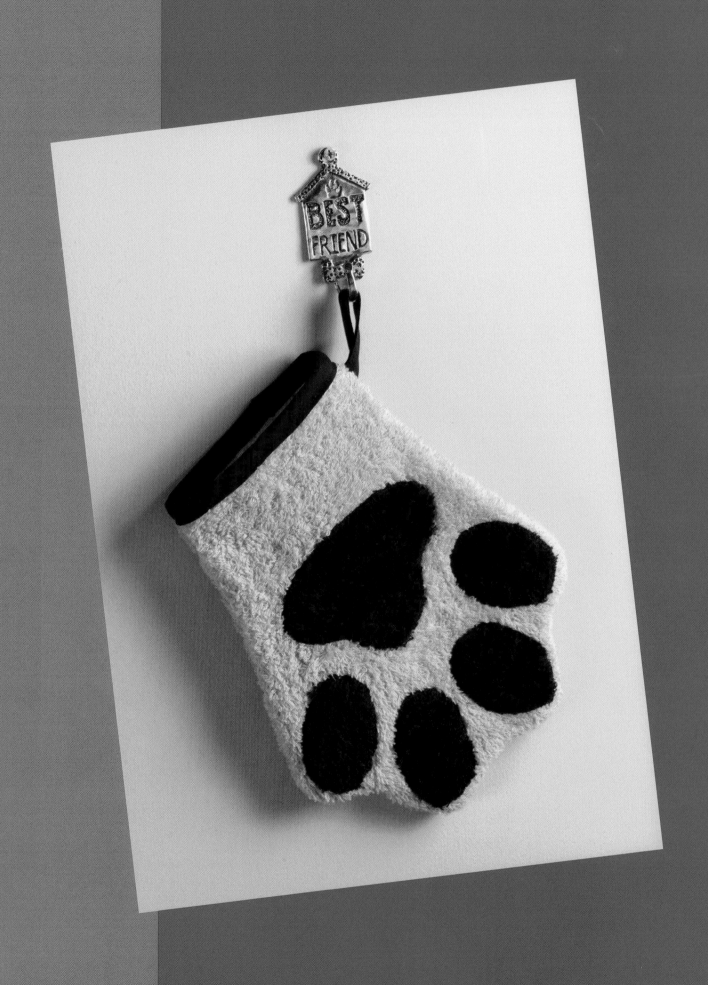

Muddy Paws
MITT

Cleaning up wet or muddy paws is a bit more fun when you're wearing this mitt. Afterward, hang the mitt to dry using the attached loop.

You can start with an inexpensive hand towel and washcloth or with terry cloth from the fabric store. When choosing the colors, keep in mind that the mitt will get dirty.

This would make a great gift for a friend with a new dog. Stuff the mitt with treats, shampoo, and a brush.

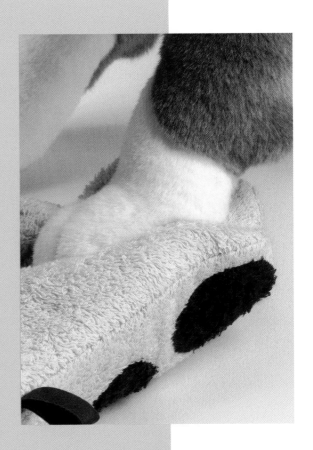

You Will Need

Pattern (page 126)

Hand towel

Wash cloth in contrasting color

Paper-backed fusible web

Water-soluble fabric stabilizer sheet

½ yd. (0.5 m) wide double-fold bias tape

Basic sewing supplies

Technique:
Water-soluble Stabilizer

Water-soluble stabilizer is available at fabric stores. It looks like a thin sheet of translucent plastic. Like other stabilizers, it adds a little support and prevents rippling. When you place it over heavily textured fabric, like this terry cloth, it keeps the appliqué stitches from getting buried. Because you can see through it, you can easily follow the edge of the appliqué. Any stabilizer that can't be torn away washes away when laundered.

1 Enlarge the mitt and appliqué patterns (page 126). Cut two mitt pieces from the towel. Transfer the placement lines for the paw prints and loop onto the front of one mitt piece.

2 Trace the paw print appliqué patterns onto paper-backed fusible web. Fuse the web onto the wash cloth, and cut out the appliqués.

3 Fuse the appliqués onto the mitt at the markings. Baste a sheet of water-soluble stabilizer (not shown in illustration) over the mitt front. Stitch through the stabilizer, around the edge of each appliqué, with a short, narrow zigzag stitch. Tear away the stabilizer.

3

4

6

4 Cut a 4" (10 cm) piece of bias tape for the hanger loop. Stitch the folded edges of the tape together. Fold the loop in half crosswise and pin to the mitt front at the dot. Machine baste in place.

5 Pin the mitt front and back right sides together. Stitch around the mitt with a ½" (1.3 cm) seam allowance, leaving the bottom open. Trim the seam allowances to ¼" (6 mm). Zigzag the edges together to finish the seams.

6 Cut a 14" (35.5 cm) length of bias tape. Unfold the tape and hold it so the narrower outer fold is on the right. Turn under ½" (1.3 cm) at the top. Pin the right side of the tape to the wrong side of the mitt opening, raw edges even. Overlap the turned-under end with the other end. Stitch in place along the fold line in the bias tape.

7 Turn the mitt right side out. Refold the bias tape, wrapping the longer outer fold to the right side of the mitt and encasing the raw edge of the mitt; pin. Edgestitch the tape in place.

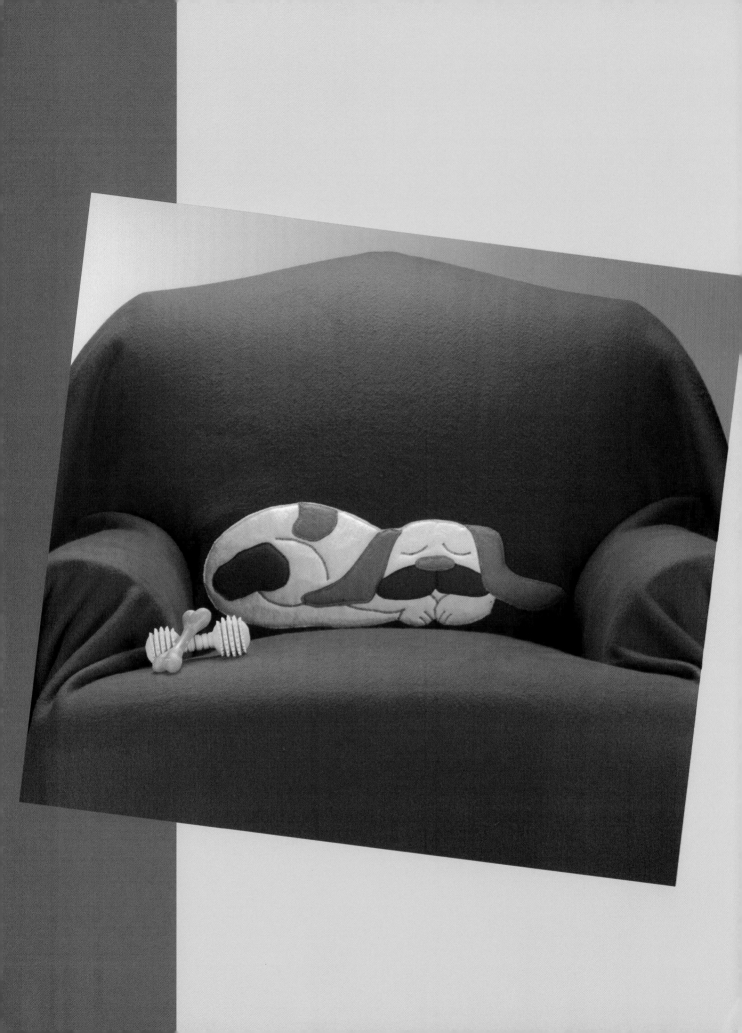

Favorite Chair
COVER-UP

Some dogs are true couch potatoes.
If your dog loves to lounge on a sofa
or chair, protect your furniture from hair
and dirt with this throw. Choose fleece
in a color that complements your room's
décor. Fleece is the softest of machine
washable materials, so there's lots of
cuddle factor.

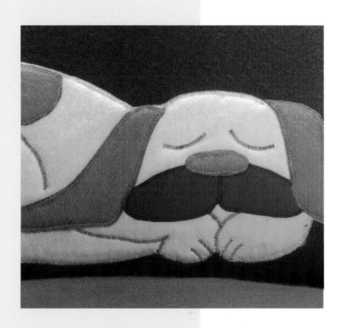

The throw is decorated with an
adorable appliqué image of a sleeping
dog. Position the appliqué at the bottom
of the chair back. Stitch the details rather
than adding button eyes, which could be
choking hazards. If you want to
personalize the image, you can alter the
outline and color to look like your own
dog. Scout lying on our couch next to
an image of a bichon is to die for.

You Will Need

1¾ yd. (1.6 m) fleece

Rotary cutter with wavy-edge blade and cutting mat

Pattern (page 119)

Steam-A-Seam 2® fusible web

Fleece scraps for appliqué

Tear-away stabilizer

Thread in colors to match or accent the appliqué

Basic sewing supplies

1 Cut the fleece to measure 60" × 40" (152.5 × 102 cm), using a wave-blade rotary cutter. Place the protector over the chair or sofa, and mark the desired location of the appliqué.

2 Enlarge the appliqué pattern (page 119). Trace the main appliqué shape and each individual shape (ears, nose, snout, spots) separately onto the paper side of Steam–A–Seam 2 fusible web (page 112). Note that the finished appliqué will be a mirror image of the pattern.

2

4

5

3 Cut out the shapes, leaving a bit of margin around each piece. Press with fingers to temporarily adhere each shape onto the wrong side of the desired color of fleece. Cut out the appliqués on the traced lines. On the right side of the main body/head appliqué, mark placement lines for features and stitching lines for eyes, paws, and leg.

4 Temporarily adhere the main body/head appliqué in place on the right side of the chair cover, using light pressure with a cool iron.

5 Temporarily adhere the remaining pieces in place on the dog's body as marked.

6 Place tear-away stabilizer (page 62) under the appliqué. Using a narrow zigzag stitch, stitch close to the edge of each piece and along the marked lines. Tear away the stabilizer.

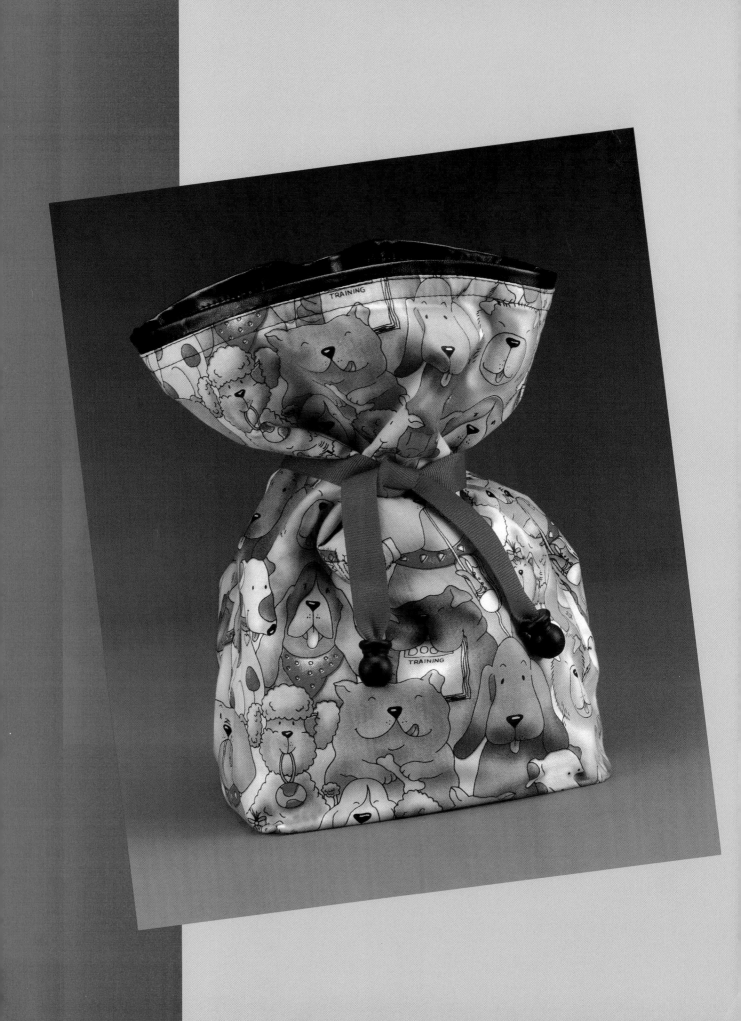

Good Dog
TREAT BAG

I recently heard a man say that if treats were involved, he could train his yellow Lab to program the VCR. It is true that many trainers recommend a combination of positive reinforcement and treats. Remember, though, that treats are also food, so if you overdo it, your dog could gain an unhealthy amount of weight. Consider treats part of your dog's total food intake for the day.

Here's a cute bag to hold treats for the times when your dog deserves a special reward. In no time, you'll have your dog's full attention every time you reach for it! The bag can be closed with the handy ties, and the vinyl lining can be wiped clean. It's a good idea to store the bag out of the dog's reach— and probably even out of sight—to avoid the risk of self-serve.

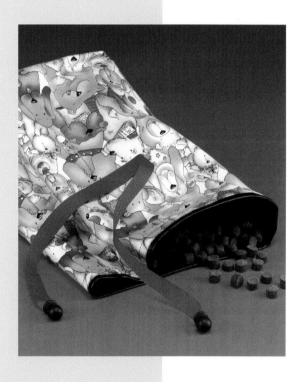

You Will Need

⅝ yd. (0.6 m) dog print fabric

⅝ yd. (0.6 m) vinyl for lining

Two wooden mini finials or wooden beads

Acrylic paint

Hot glue gun

½ yd. (0.5 m) ribbon, ⅝" (15 mm) wide

Basic sewing supplies

1 Cut two rectangles 12½" (31.8 cm) long by 10½" (26.7 cm) wide from the bag fabric. Repeat for the lining fabric. Place the bag pieces right sides together, and stitch along the side and bottom edges with a ½" (1.3 cm) seam allowance. Press the bag seams open.

2 Refold one bottom corner so the side seam is over the bottom seam. Stitch across the corner 1½" (3.8 cm) from the point, forming a triangle. Repeat with the other corner to square off the bag bottom.

2

5

6

3 Repeat steps 1 and 2 for the lining, leaving a 4" (10 cm) opening in one side seam for turning.

4 Place the lining inside the bag with right sides together. Stitch along the upper edge with a ½" (1.3 cm) seam allowance. Turn the seam toward the bag. Turn the bag right side out through the opening in the lining. Slipstitch the opening closed.

5 Tuck the lining inside the bag, leaving ¼" (6 mm) of the lining extending beyond the top of the bag. Topstitch close to the seam.

6 Paint the mini finials with acrylic paint. Tuck the ribbon ends inside the finials and glue in place.

7 Center the ribbon on the back of the bag, 4" to 5" (10 to 12.7 cm) from the top, and stitch the ribbon in place with a few machine stitches.

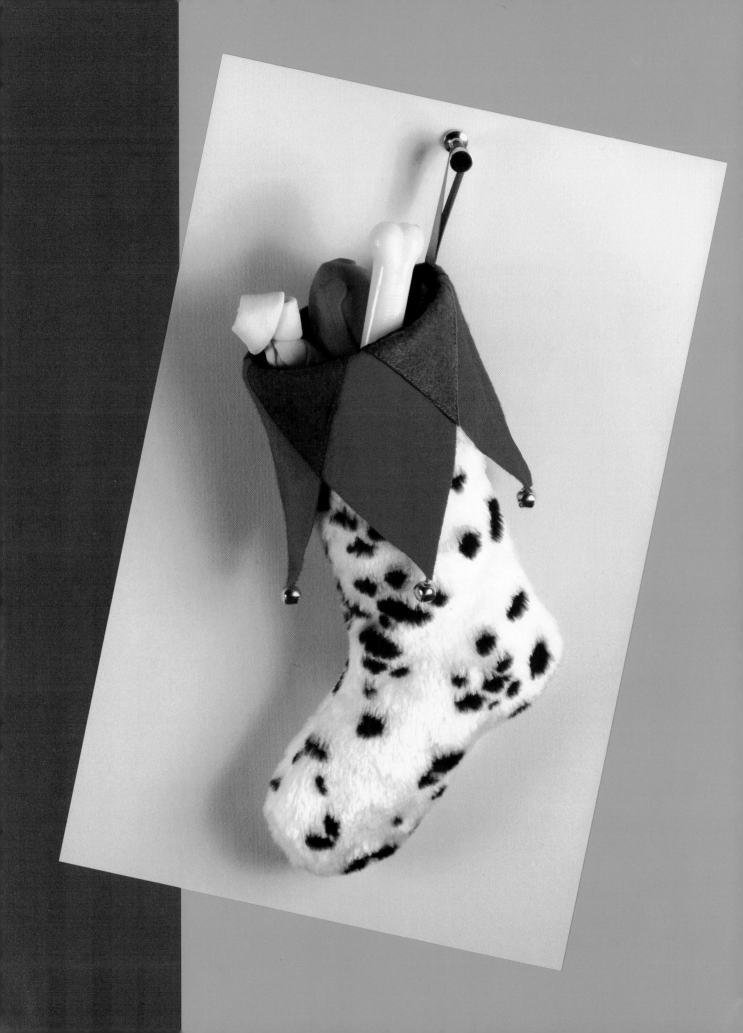

Merry, Furry
STOCKING

A dog who celebrates Christmas

needs a stocking. Sure, you could buy
one, but isn't a homemade Christmas
stocking always better? This faux fur
stocking can be easily adapted for any
breed. Just find the "fun fur" that best
matches your dog's coat. The one
pictured here obviously belongs to a
Dalmatian. A jester cuff seems quite
appropriate, as most of our dogs are
jokers at times. Fill the stocking
with treats, and have a very furry
fun Christmas.

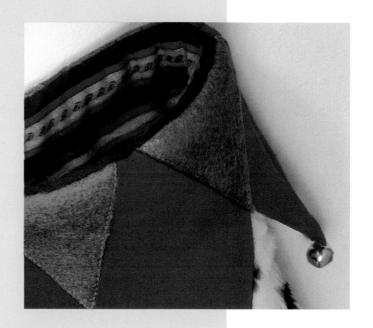

You Will Need

Pattern (page 125)

⅝ yd. (0.6 m) faux fur

⅝ yd. (0.6 m) fabric for lining

¼ yd. (0.25 m) each green and red felt

6" (15 cm) ribbon, ⅝" (9 mm) wide

Four small bells

Basic sewing supplies

1 Enlarge the stocking, cuff, and triangle patterns (page 125). Cut two stocking pieces from faux fur and two lining pieces.

2 Pin the stocking pieces right sides together and stitch along the sides and foot with ¼" (6 mm) seam allowances. Turn the stocking right side out.

3 Cut one cuff piece from the red felt. Cut four accent triangles from the green felt. Stitch the four green triangles in place over the red cuff. Stitch the free side of the last green triangle to the upper side of the opposite end of the cuff, joining the cuff to form a circle.

3

4

4 Place the cuff over the stocking and baste along upper edge.

5 Pin the lining pieces right sides together and stitch along the side and foot with ¼" (6 mm) seam allowances. Leave a 4" (10 cm) opening in the bottom for turning.

6 Fold the ribbon in half. Pin the ends of the ribbon to the right side of the stocking top, just behind the back seam. Place the outer stocking inside the lining, right sides together; pin. Stitch around the upper edge with ¼" (6 mm) seam allowances. Turn the stocking right side out through the opening in the lining.

7 Stitch the opening closed. Stitch a bell to each point on the cuff.

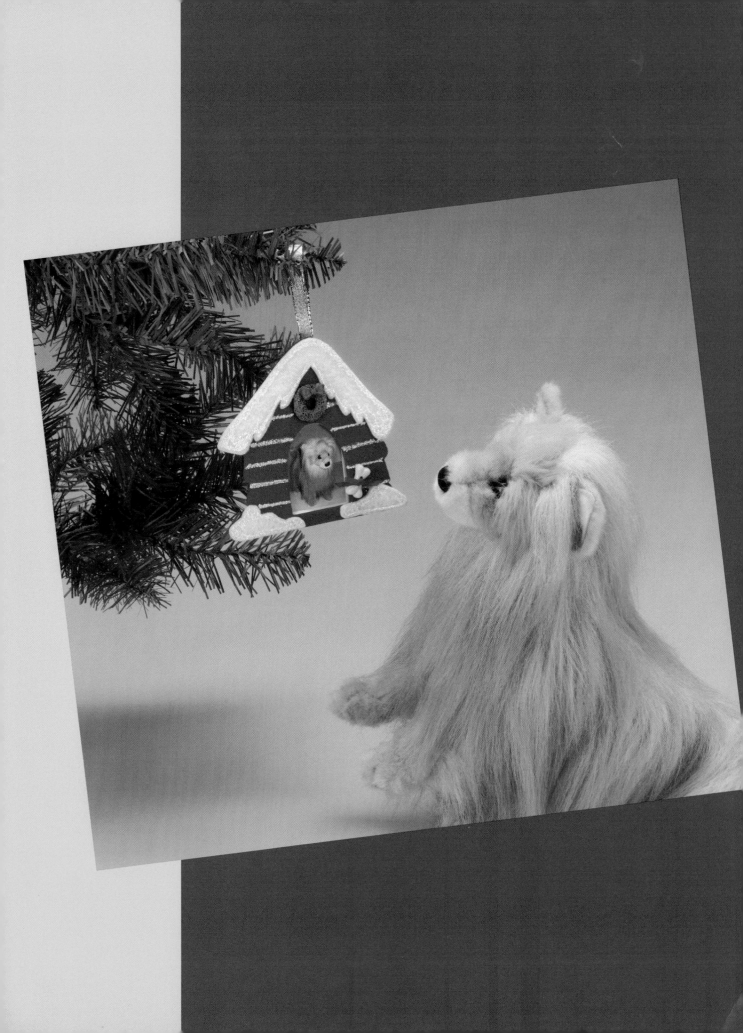

My Doghouse
ORNAMENT

This no-sew ornament with your dog's photograph is an easy project. Make one for yourself or as a gift to another dog lover–or another dog. If you like, write the dog's name and the year above the picture.

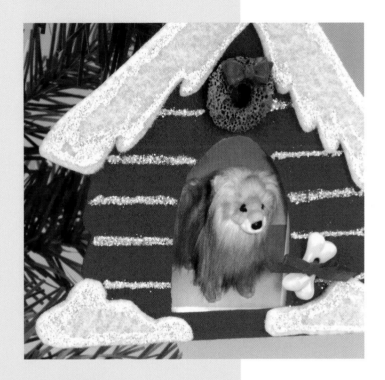

You Will Need

Pattern (page 126)

Scraps of red and white craft felt

6" (15 cm) metallic ribbon,
⅜" (9 mm) wide

Craft glue

White glitter paint

Small bone-shaped button or
other decoration

Small resin wreath

Close-up photo of your dog

1 Trace the ornament patterns onto paper. Cut one snowy roof and two snow drifts from white felt. Cut one ornament front and one ornament back from red felt. Cut out the door on the front piece.

2 Fold the ribbon in half and glue it to the wrong side of the ornament front at the peak of the roof.

2

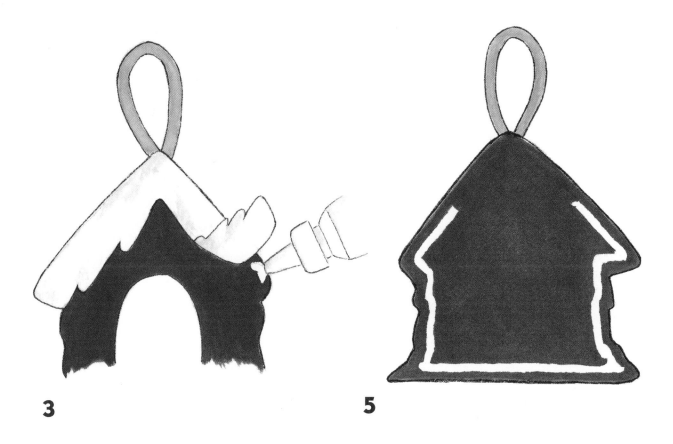

3

5

3 Glue the snowy roof to the front of the ornament, aligning the upper edges of the roof. Repeat with the snow drifts, aligning the bottom edges of the snow with the bottom edge of the ornament.

4 Decorate the house and the snow with glitter paint. Glue the dog bone and wreath in place.

5 Glue the ornament back to the wrong side of the ornament front along the side and bottom edges. Allow the glue to dry. Slip a photograph of your dog into the ornament through the top opening.

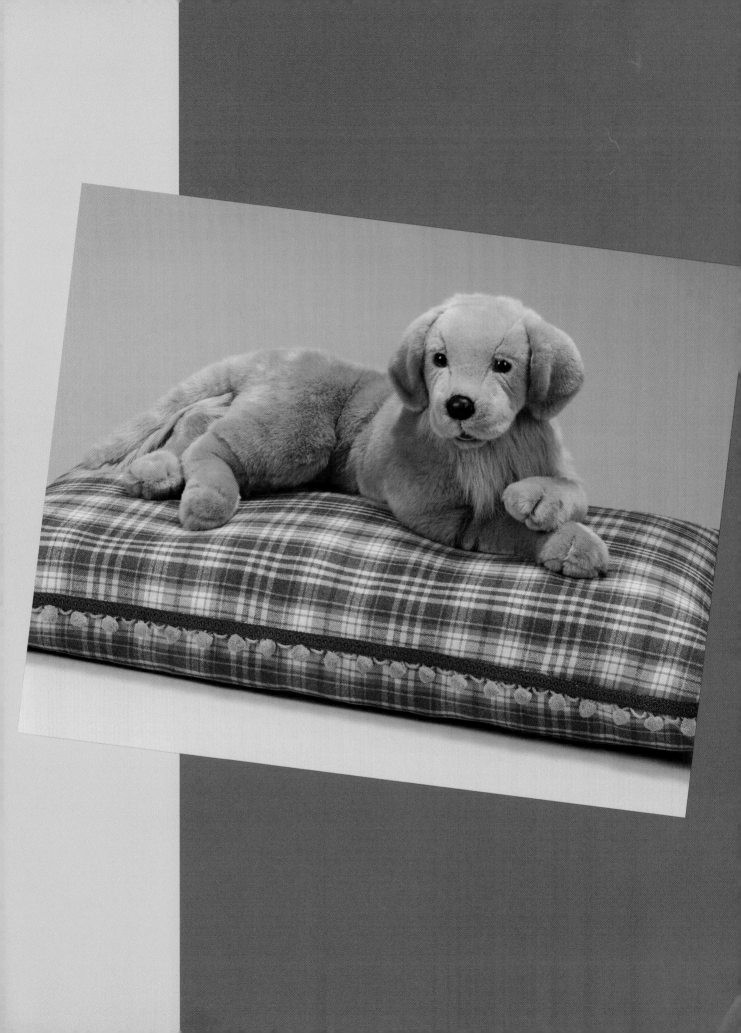

Décor
DOG NEST

Dogs spend so much time sleeping that a comfortable bed is one of the nicest projects you can make. You gain, too, because the dog's bed can be designed to complement your home décor! We chose a pretty decorator fabric, but the options are endless: fleece, flannel, cotton velvet, shearling, terry cloth. Think soft, think washable. Add trim for a final decorator touch, unless your dog is a puppy or a chewer.

The bed is constructed like a mock-box pillow. For the inside, you can use a purchased pillow form; they're available in many sizes at fabric stores or pet shops and from specialty mail-order catalogs, such as L.L. Bean.

No doubt your pooch will spend hours on this pillow, and why not?

You Will Need

Pillow form in desired size

Medium to heavyweight decorator fabric, amount determined by pillow size

Zipper, at least 4" (10 cm) shorter than one long side of pillow

Basting tape

Transparent tape, ½" (1.3 cm) wide

Ball fringe, amount equal to pillow circumference (optional)

Flat braid trim, amount equal to pillow circumference (optional)

Paper-backed fusible web tape, ½" (1.3 cm) wide, or hot glue gun (optional)

Basic sewing supplies

1 Measure the pillow form from seam to seam in both directions. Cut a dog nest front and back, each 1" (2.5 cm) larger in both directions than the pillow form. Pin the front and back, right sides together, along one long edge. Center the zipper alongside the pinned edges, and mark the seam allowances even with the zipper stops.

2 Stitch a seam with ⅝" (1.5 cm) allowances from each end to the mark, backstitching at the marks. Then increase the stitch length and baste the rest of the seam between the marks. Press the seam allowances open.

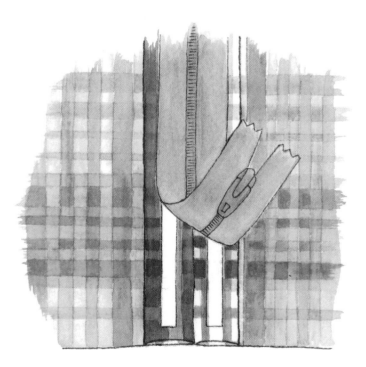

3

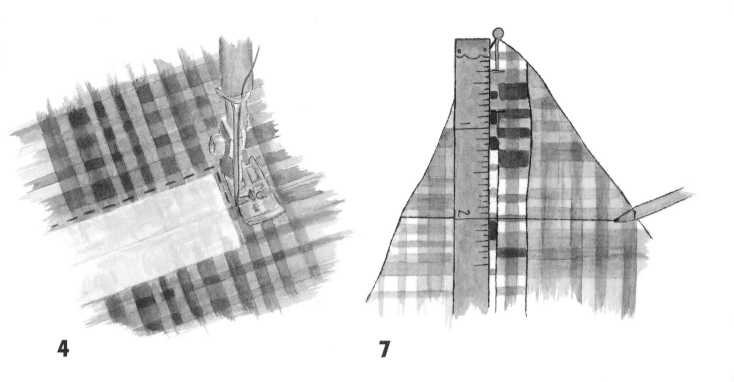

4

7

3 Apply basting tape to the seam allowances. Place the zipper facedown over the seam allowances, with the zipper coil over the seam and the stops at the marks. Press with fingers to secure.

4 Turn the fabric over to the right side. Mark the top and bottom stops of the zipper with pins. Center a strip of ½" (1.3 cm) transparent tape over the seam between the pins. Attach a zipper foot to the sewing machine. Using the tape edge as a guide, stitch down one side of the zipper, across the end below the zipper stop, up the other side, and across the other end. You will be stitching through the fabric, seam allowances, and zipper.

5 Remove the tape. Remove the basting stitches, using a seam ripper. Open the zipper partway.

6 Pin the remaining edges of the front and back right sides together. Stitch with ⅝" (1.5 cm) seam allowance. Press the seams open.

7 Separate the layers and center the seams over each other at one corner. Pin through the seams to be sure they are aligned. Draw a stitching line perpendicular to the seams 2" (5 cm) from the corner. Stitch on the marked line.

8 Repeat step 7 at each corner. Do not trim the fabric at the corners. Turn the nest right side out through the zipper opening.

9 Secure decorator trim above the seam, if desired, using paper-backed fusible adhesive or a hot glue gun. Insert the pillow form and close the zipper.

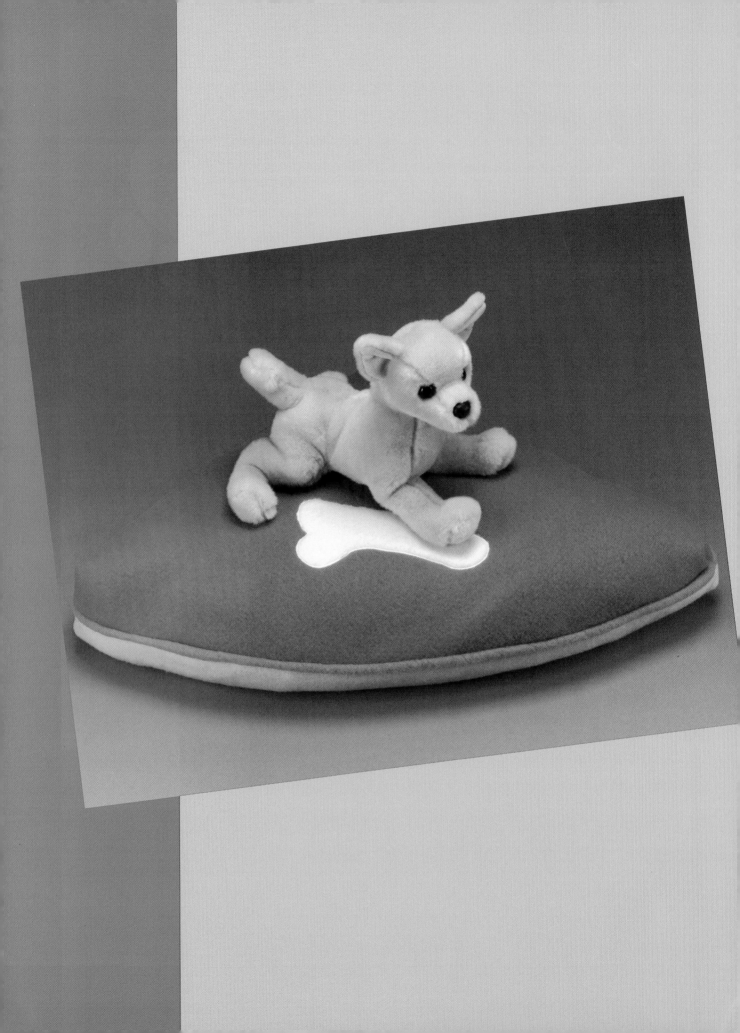

Cuddly Corner
NEST

People often buy beds that are too big for their dogs because they believe that's what dogs prefer. Not so. Dogs like to curl up in a small, secure place. Where better to nestle than the corner of the room on this special bed? A bonus for you is that a corner bed takes up less space in the room.

The measurements used here make a nest 20" (51 cm) across, which is perfect for a small dog. You can easily increase the size by starting with larger pieces of fabric.

We used soft fleece in ultra-bright colors for a fun look, but of course you can style the bed to suit your taste—and your dog's presumed taste. The nest is stuffed with a combination of loose fiberfill (for fluff) and cedar chips (for odor control). A liner holds the filling so you can remove the cover for washing.

You Will Need

¾ yd. (0.7 m) muslin for insert

String and pencil

¾ yd. (0.7 m) each of two colors of fleece

Polyester fiberfill

Cedar chips

Scrap of white fleece for bone appliqué

Steam-A-Seam 2® fusible web

Tear-away stabilizer

½ yd. (0.5 m) fleece for welting

2¼ yd. (2.1 m) polyester cording, ¼" (6 mm) diameter

16" (40.5 cm) adhesive-backed hook and loop tape, ½" (1.3 cm) wide

Basic sewing supplies

1 Cut a 22" (56 cm) square of muslin. Tie a piece of string to a pencil. Pin the string to one corner of the square 22" (56 cm) from the pencil. Pulling the string taut, mark an arc on the muslin. Cut along the marked line. Using this piece as a pattern, cut a second piece of muslin and one each of the two fleece fabrics.

2 Stitch the two pieces of muslin together around the edges, with ½" (1.3 cm) seam allowance, leaving an opening in the center of one side for turning. Turn the liner right side out.

3 Stuff the liner with the polyester fiberfill and cedar chips. Stitch the opening closed.

Technique:
Steam-A-Seam 2

This fusible web is sticky on both sides so it can be temporarily positioned on both the appliqué and the background fabric without heat fusing. This is very useful for fabrics like fleece that can be damaged by pressing.

5

7

4 Draw a bone onto the paper backing of the Steam-A-Seam 2 fusible web. Remove the loose paper from the other side, exposing the sticky coating. Stick the fusible web onto the back of the white fleece. Cut out the appliqué. Remove the paper backing and adhere the appliqué to the right side of the nest top.

5 Apply tear-away stabilizer (page 62) under the appliqué. Stitch around the appliqué with a narrow zigzag stitch.

6 Cut two 2" (5 cm) strips of fleece on the crosswise grain, for the welting. Join the strips end to end, right sides together, with a diagonal seam. Trim away the excess, leaving $\frac{1}{4}$" (6 mm) seam allowances. The finished strip should be about 80" (203.5 cm) long.

7 Center the cording on the wrong side of the strip. Fold the strip over the cording, aligning the raw edges. Using a zipper foot set to the right side of the needle, machine-baste close to the cording.

continued

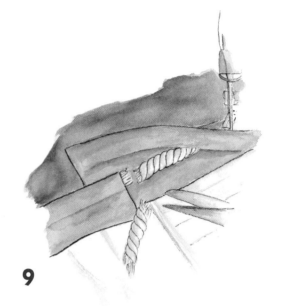

8

9

8 Stitch the welting to the right side of the nest top, raw edges even, stitching over the basting stitches. Begin stitching 2" (5 cm) from the end of the welting. Clip into the welting seam allowances at the corners to keep the welting flat.

9 Stop stitching 2" (5 cm) from the point where the cording ends will meet. Leaving the needle in the fabric, cut off one end of the welting so it overlaps the other end by 1" (2.5 cm). Remove the last 1" (2.5 cm) of cording from inside the overlapping end of the welting so the cord ends just meet. Tuck the beginning of the welting inside the overlapping end, and finish stitching.

10 Pin the top and bottom nest pieces, right sides together, on the curved edge and one straight edge. Secure the hook and loop tapes together, and remove the paper backing from one side. Center the hook and loop tape, adhesive side down, on the open side of the nest between the seam allowances. Press with the fingers to adhere. Remove the paper backing from the other side and adhere it to the other seam allowance.

11 Stitch the nest front and back together with ½" (1.3 cm) seam allowances, beginning and ending at the ends of the hook and loop tape. With the previous stitching line on top, stitch just inside the previous stitches.

12 Open the hook and loop tape and turn the nest right side out. Fill the nest with the muslin liner.

PATTERNS

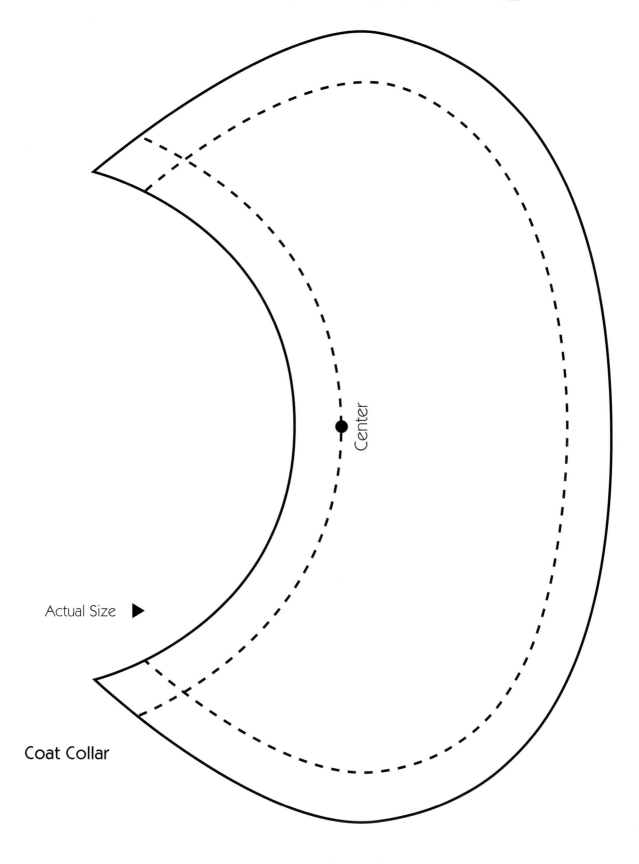

Center

Actual Size ▶

Coat Collar

Patterns

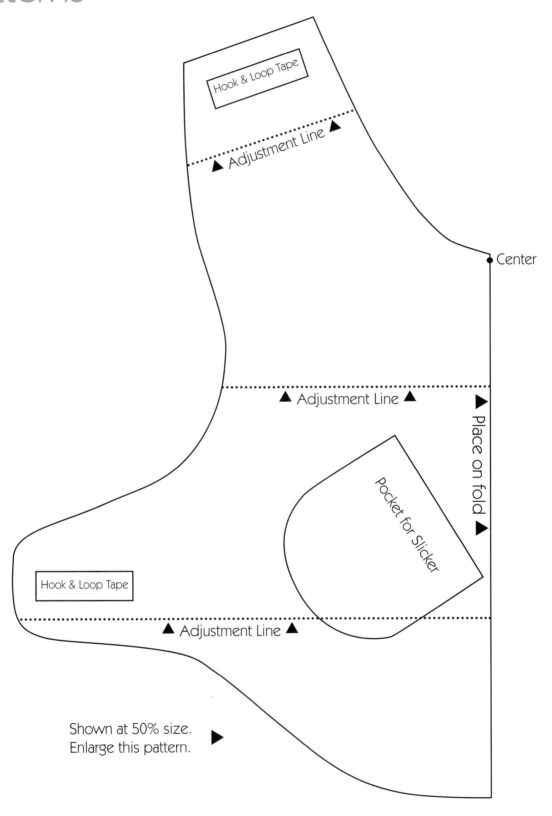

Hook & Loop Tape

Adjustment Line

Center

Adjustment Line

Place on fold

Pocket for Slicker

Hook & Loop Tape

Adjustment Line

Shown at 50% size.
Enlarge this pattern.

Slicker or Coat

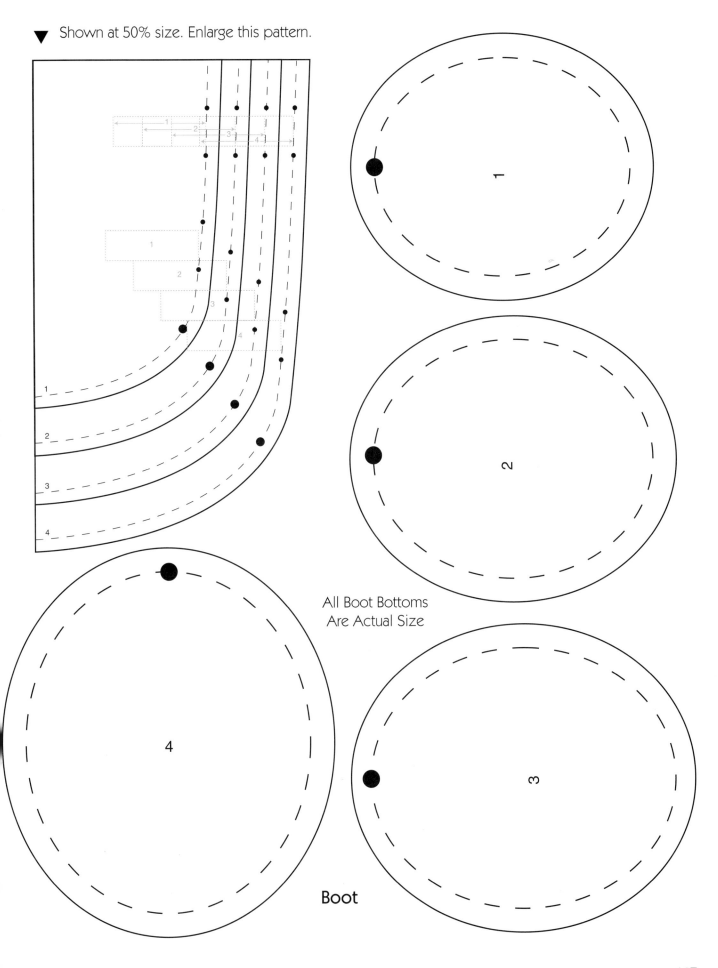

▼ Shown at 50% size. Enlarge this pattern.

1

2

3

4

1

2

3

4

All Boot Bottoms
Are Actual Size

Boot

Patterns

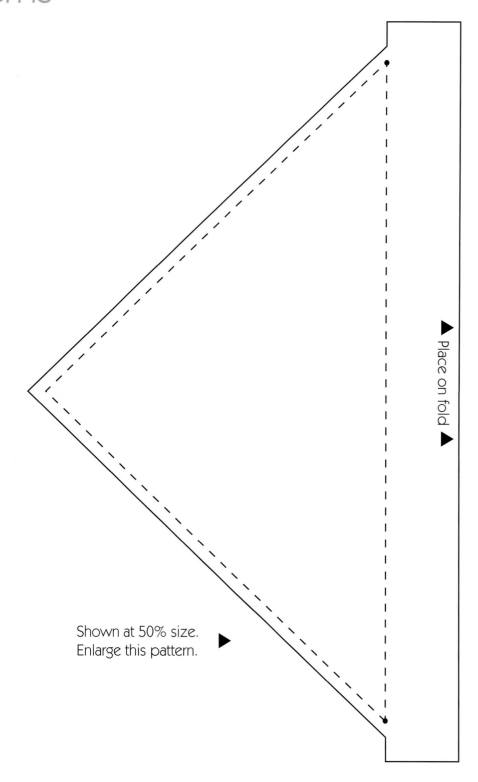

Place on fold ▶

Shown at 50% size.
Enlarge this pattern. ▶

Bandana

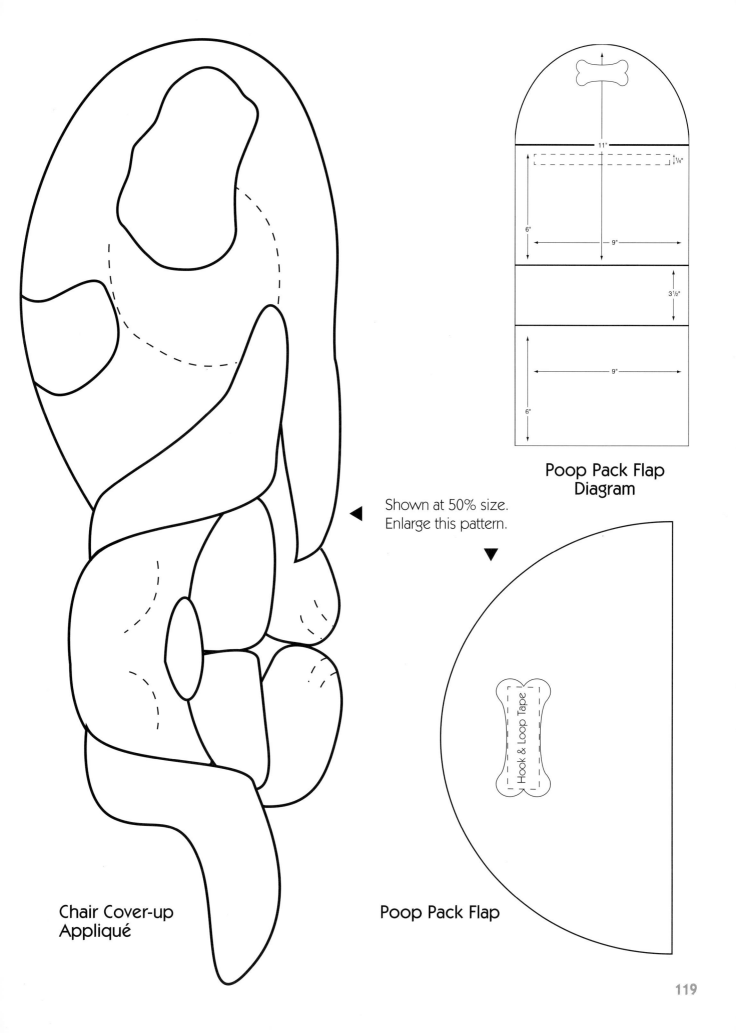

Poop Pack Flap
Diagram

11"

1/4"

6"

9"

3 1/2"

9"

6"

Shown at 50% size.
Enlarge this pattern.

Chair Cover-up
Appliqué

Poop Pack Flap

Hook & Loop Tape

Patterns

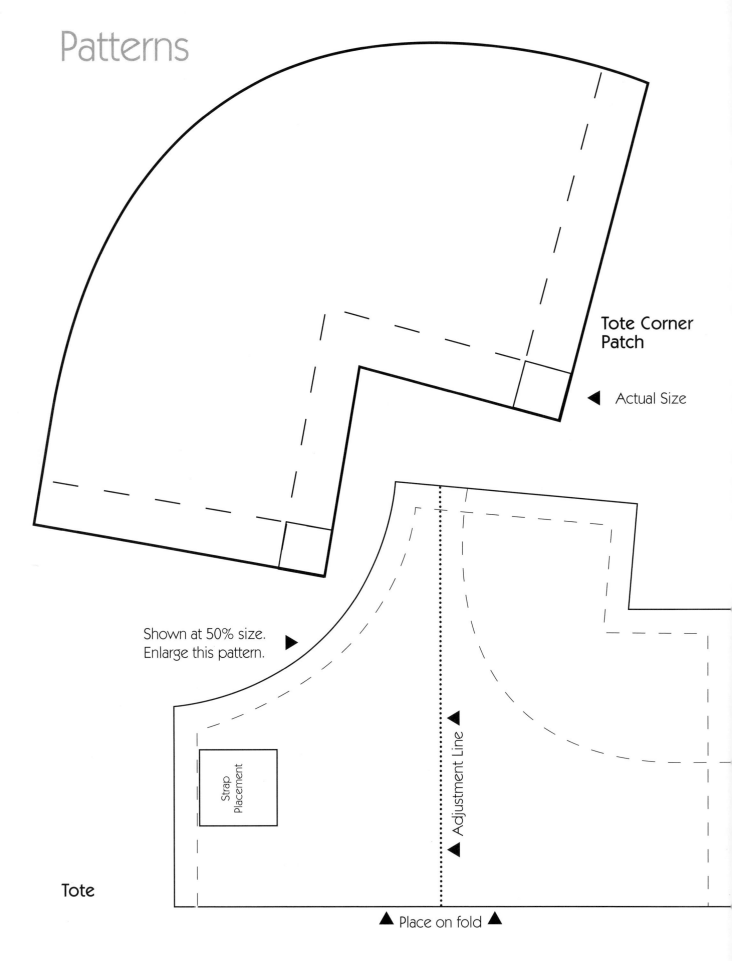

Tote Corner
Patch

◄ Actual Size

Shown at 50% size.
Enlarge this pattern. ►

Strap
Placement

◄ Adjustment Line ◄

Tote

▲ Place on fold ▲

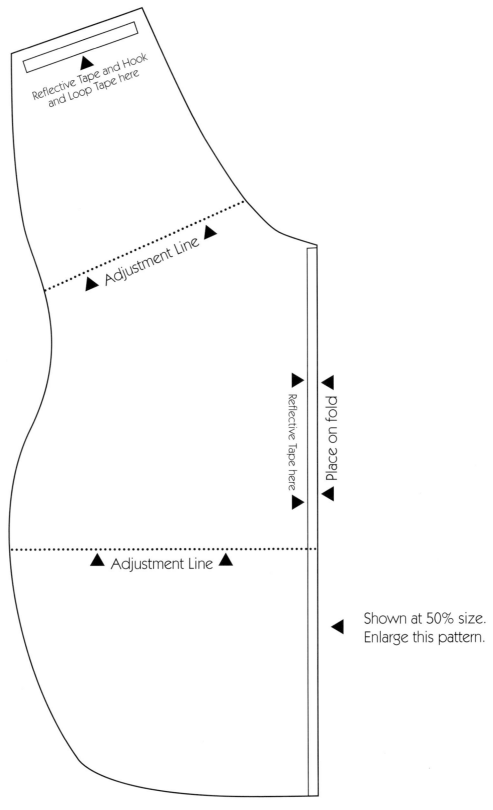

Reflective Tape and Hook and Loop Tape here

Adjustment Line

Reflective Tape here

Place on fold

Adjustment Line

Shown at 50% size.
Enlarge this pattern.

Safety Vest

Patterns

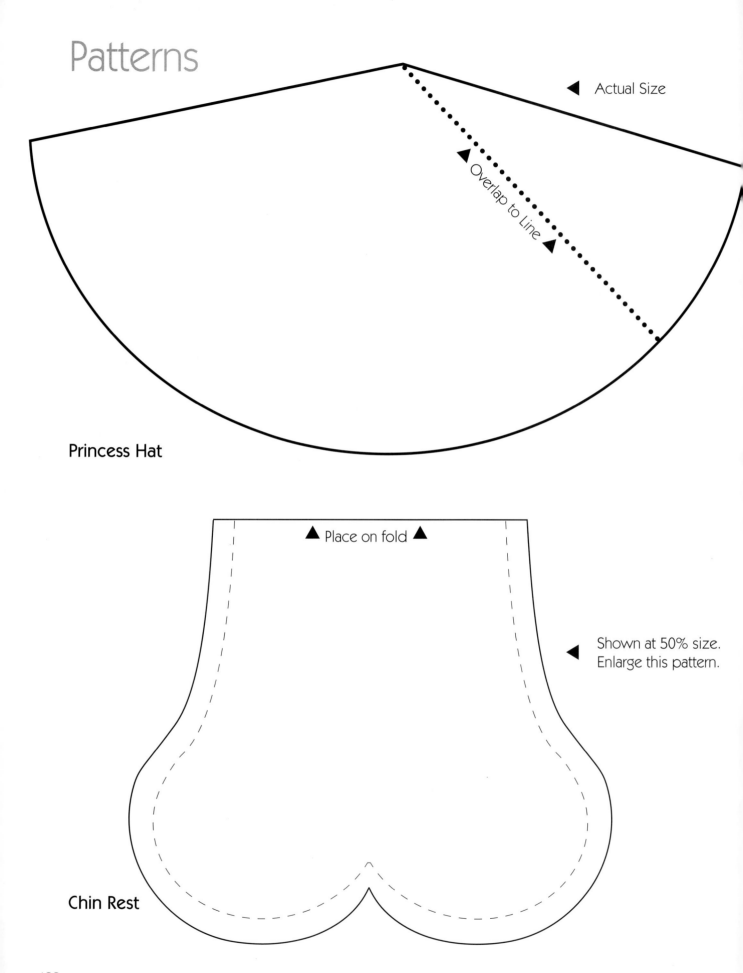

Actual Size

Overlap to Line

Princess Hat

▲ Place on fold ▲

Shown at 50% size.
Enlarge this pattern.

Chin Rest

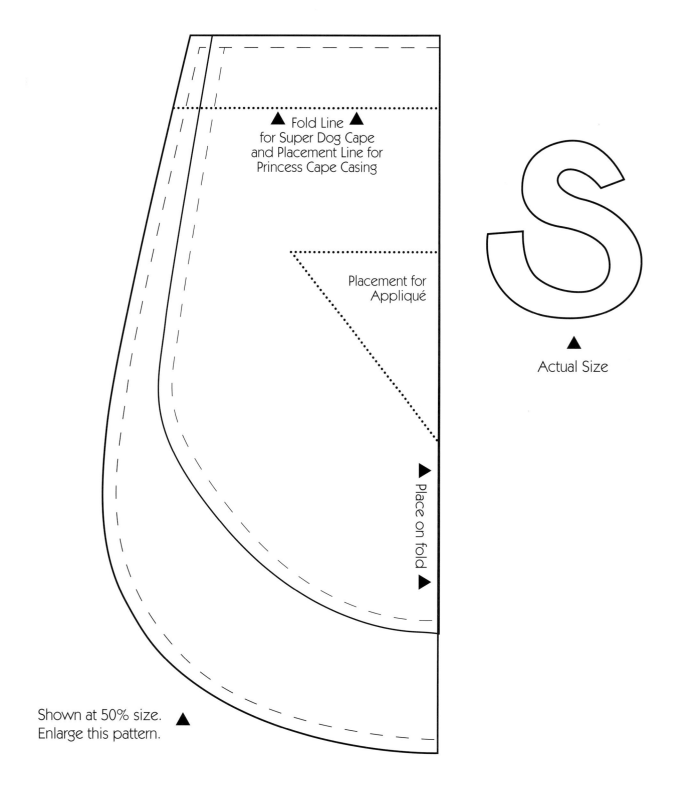

▲ Fold Line ▲
for Super Dog Cape
and Placement Line for
Princess Cape Casing

Placement for
Appliqué

Place on fold ▶

▲
Actual Size

Shown at 50% size. ▲
Enlarge this pattern.

Princess and Superdog Capes

Patterns

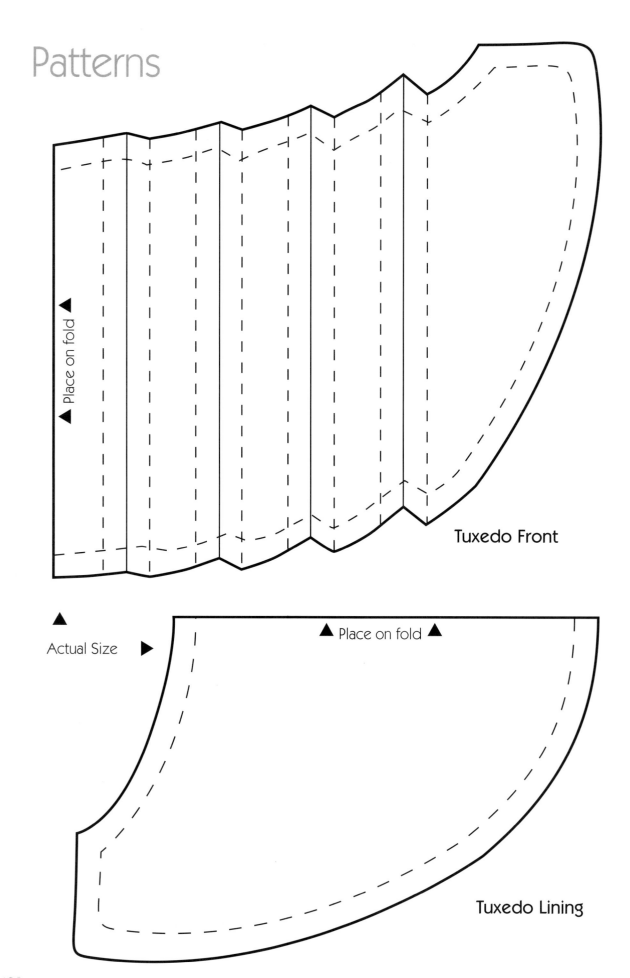

◄ Place on fold ◄

Tuxedo Front

▲
Actual Size ▶

▲ Place on fold ▲

Tuxedo Lining

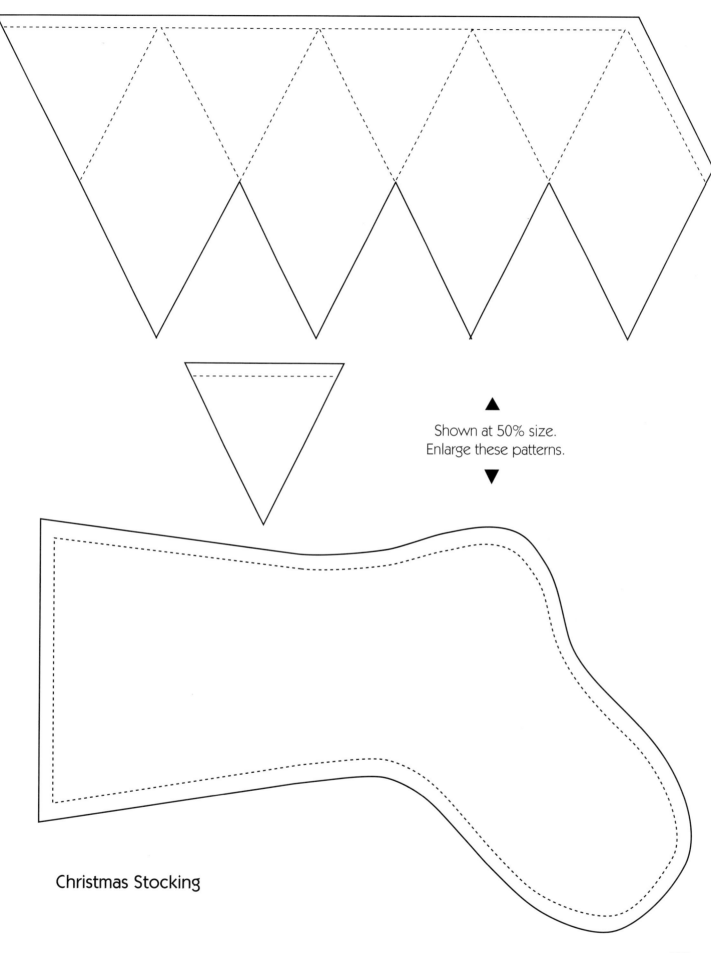

Shown at 50% size.
Enlarge these patterns.

Christmas Stocking

Patterns

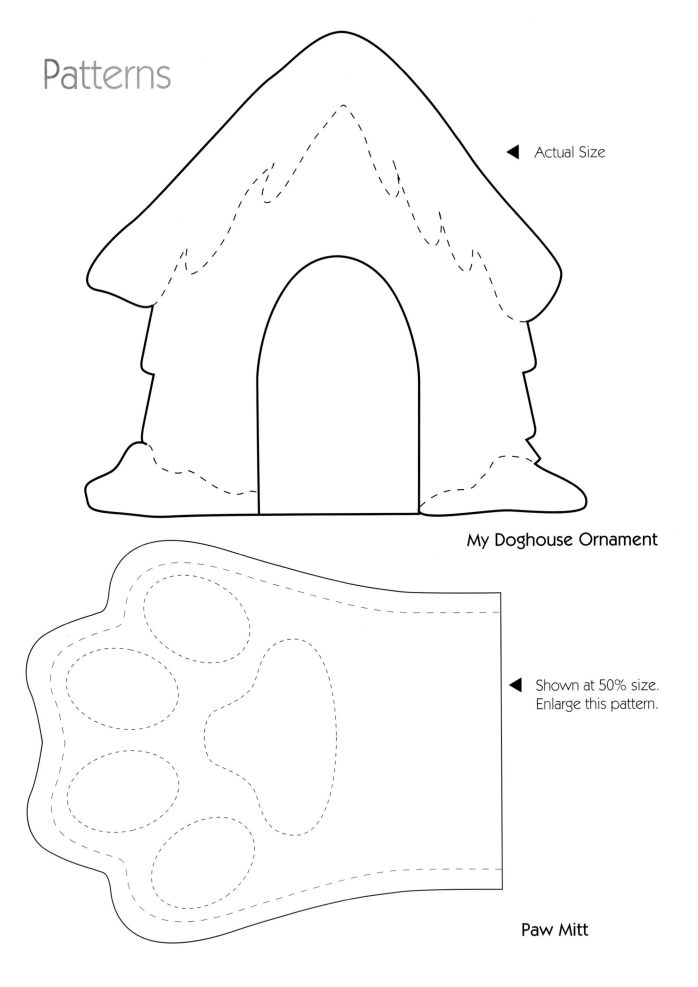

◀ Actual Size

My Doghouse Ornament

◀ Shown at 50% size.
Enlarge this pattern.

Paw Mitt

RESOURCES

ahh.biz
Route 4, Box 86
Squires, MO 65755
Phone: 866-458-2559
Fax: 417-683-1679
www.ahh.biz
(nylon for boots, bags, etc)

B & J Fabrics
525 Seventh Avenue
New York, NY 10018
Phone: 212-354-8150
Fax: 212-764-3355
www.bjfabrics.com
(any odd fabrics:
yellow vinyl, etc)

David Textiles, Inc.
Toll Free: 800-548-1818
(fleece)

Ironhorse Safety Specialties
9886 Chartwell
PO Box 551548
Dallas, TX 75243
Phone: 214-341-9947
Toll Free: 800-323-5889
Fax: 214-340-7775
www.reflectivefabric.com
(3M reflective fabric)

Strapworks.com
1140 1st Street
Springfield, OR 97477
Phone: 541-741-0658
Fax: 541-741-7625
www.strapworks.com
(plastic clips, Drings,
easy-clasp clips, etc.)

Ultrastyle Design
813 Moffat Court
Castle Rock, CO 80108
Phone: 720-733-8949
Toll Free: 866-733-8949
Fax: 303-688-4942
www.ultrastyledesigns.com
(bulk ultrasuede)

Velcro USA
www.velcro.com
(hook and loop tape)

Waverly
www.waverly.com
(plaid fabric for dog nest)

For the technology-savvy sewers who can access the Internet, there are endless fabric resources. For example, if you are looking for fake fur, go to your favorite search engine and enter "fake fur by the yard."

Many thanks to Douglas Cuddle Toys
for providing the dog "models." You can find their dogs and other animals at a gift or toy store near you. For store locations, check their website: www.douglascuddletoy.com.

INDEX